IMAGES
of America

NEW YORK
YANKEES
THE FIRST 25 YEARS

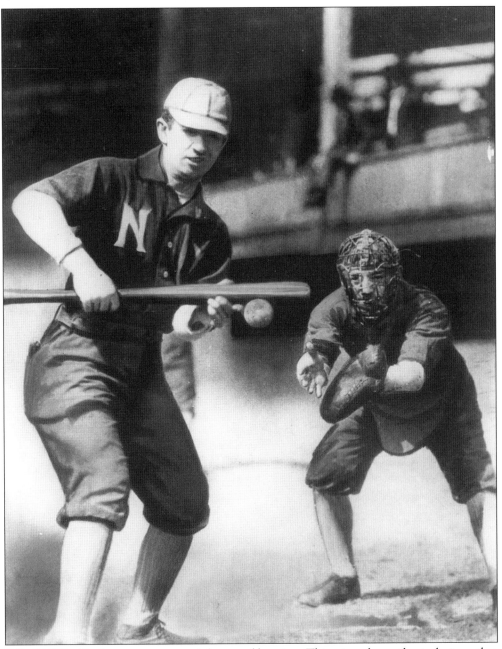

"Wee" Willie Keeler was a master of the art of bunting. This view shows the technique that made him famous. His old saying was "Hit 'em where they ain't." He played with the Highlanders between 1903 and 1909. His best batting average was .343 in 1904. His $10,000 salary was the highest in the American League.

IMAGES
of America

NEW YORK YANKEES
THE FIRST 25 YEARS

Vincent Luisi

ARCADIA

First printed in 2002.

Published by Arcadia Publishing,
an imprint of Tempus Publishing, Inc.
2A Cumberland Street
Charleston, SC 29401

Printed in Great Britain.

Library of Congress Catalog Card Number: 2001097954

For all general information contact Arcadia Publishing at:
Telephone 843-853-2070
Fax 843-853-0044
E-Mail sales@arcadiapublishing.com

For customer service and orders:
Toll-Free 1-888-313-2665

Visit us on the internet at http://www.arcadiapublishing.com

*To my grandfather, who took me to the ballpark
to enjoy many years of baseball together, and to my adoring
little girl, Erin, who has given me the most precious memory
of her coming with me to see her first Yankee ballgame.*

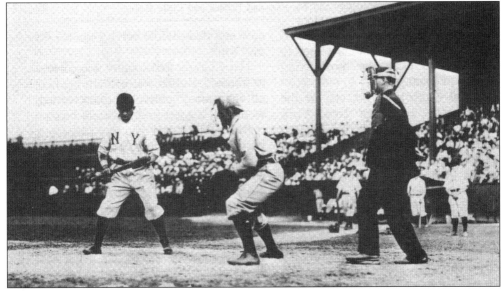

"Wee" Willie Keeler is shown batting for the New York Highlanders at Hilltop Park in a 1908 game against the Boston Americans.

CONTENTS

ACKNOWLEDGMENTS

This book took a lot of effort and assistance from many individuals and various institutions. Without their assistance, this project could not have been completed. Although I have used many photographs from my own collection, others have generously allowed me to access their collections. First, I would like to thank George Steinbrenner and the New York Yankees for allowing me the opportunity to use their photographic archives. The Yankees personnel who were instrumental in helping me include Rick Cerrone, media relations director, and Joa Martin, media relations assistant, who spent time with me to sort out photographs. Photographs are also included from the collection of the National Baseball Hall of Fame. Many thanks go to William C. Burdick, senior photograph researcher. Barry Halper was helpful for his special skills regarding baseball history and his Yankee photograph collection. Marc Okkonen shared his work on early-20th-century baseball and his excellent source on baseball uniforms. George Stapp, owner of Cross Products, allowed me to use his private collection of Yankee Stadium photographs as listed on his Web site. Other people and organizations that allowed the use of photographs include the Library of Congress, the New York Public Library, Joan Penn and Maile Chaffin-Quiray at the Presbyterian Hospital of New York (Columbia-Presbyterian Medical Center), the Sporting News, United Press International, and Pinellas County Museum curator Don Ivey.

Special thanks go to Jack Zweck for his editing and advice, Van Nix for his computer assistance, Sandy Kinzer for typing, and the volunteers at the Dunedin Historical Museum. Thanks also go to my good friend Al Micucci, who took on the chore of research assistant and technical advisor for my historical facts. We go back a long way, and I was glad to have him along for the ride.

Sources used for facts and data include *The Yankee Encyclopedia*, by Harvey Frommer; *Baseball Memories and Baseball Uniforms of the 20th Century*, by Marc Okkonen; *New York Yankees*, by Donald Honig; *The Yankees*, by Phil Pepe; *Yankee Stadium*, by Joseph Durso; *Lost Ballparks*, by Lawrence S. Ritter; *Yankees Illustrated History*, by George Sullivan and John Powers; *Baseball: An Illustrated History*, by Geoffrey Ward and Ken Burns; and *Yankee Stadium*, by Ray Robinson and Christopher Jennison.

INTRODUCTION

Baseball history lists the New York Yankees as one of the most successful teams of the 20th century. No other club has held more titles or has won more World Series championships. As we slide into the 21st century, the Yankees celebrate their 100th anniversary as an American League team.

The team was formed in 1903 from the remnants of a failing American League team, the Baltimore Orioles. Two years after the establishment of the American League in 1901, two New Yorkers—Frank Farrell and Bill Devery—purchased the Baltimore team for $18,000 and moved the franchise to New York. After many complicated plans and political maneuvering, the team built a wooden stadium called Hilltop Park. Overlooking the Hudson River on Broadway and 168th Street, the stadium was located in Washington Heights. The new team was to be called the Highlanders, as Washington Heights was the highest point of land in Manhattan. (Although several theories exist to explain the choice of team name, this one is perhaps the most plausible.) The team remained at Hilltop Park until the 1913 season, when they were invited to share the Polo Grounds with the New York Giants until they could build a new stadium in another location. During that season, the Highlanders forever cemented their new official name into baseball history—the New York Yankees. After sharing the Polo Grounds with the Giants for 10 years (including playing opposite each other in the World Series), the Yankees moved to their stadium. Dedicated on April 23, 1923, Yankee Stadium would become the place where legends would grow.

One
THE HIGHLANDERS
(1903–1912)

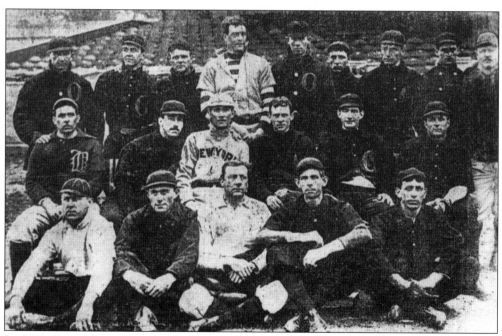

In 1901, Ban Johnson organized the American League. The league included the Baltimore Orioles, led by John McGraw and players such as Joe Kelly and Wilbert Robinson. The players are pictured in their 1901 road uniforms, which featured the letter O on the left side of the shirt. McGraw is fourth from the left in the middle row. Two years of disappointing attendance resulted in the sale of the team to New York.

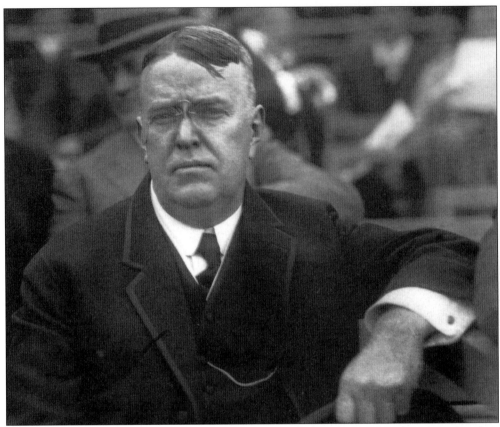

Ban Johnson founded the American League in 1901 and served as its president. He played an important role in the Highlanders coming to New York.

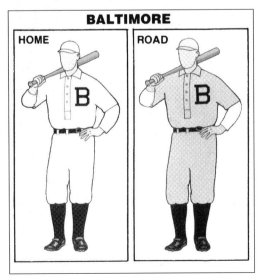

By July 1902, Orioles manager John McGraw would leave Baltimore and go to the National League to manage the New York Giants. Other team members started to leave as well. The remaining members of the 1902 team included Charles Shields (pitcher and outfielder), Billy Gilbert (shortstop), Andy Oyler (infielder), Albert "Kip" Selbach (outfielder), Dan McGann (first baseman), I.I. Mathison (infielder), Tom Jones (second baseman), Herb McFarland (outfielder), Roger Bresnahan (utility), "Long Tom" Hughes (pitcher), and Wilbert Robinson and Joe Kelly as co-managers. It would take 52 years before Baltimore would again be an American League team. The team had drastically changed its uniform from the previous season. (Courtesy Marc Okkonen.)

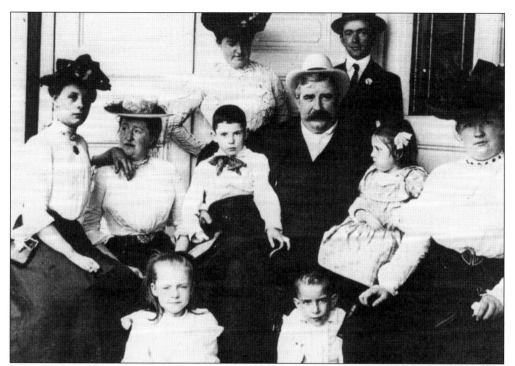

"Big" Bill Devery and Frank Farrell, with the influence of Ban Johnson, acquired the failing Baltimore franchise for $18,000 and transferred the team to New York. Devery, seen in the early 1900s with his family, was a former New York City chief of police who was known for his allegedly corrupt dealings during the Tammany Hall era. He had the influence to get approval to build a baseball stadium for his team.

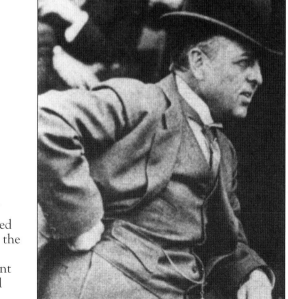

Frank Farrell, Devery's partner in the American League team, owned several gambling establishments and a stable of racehorses. It was his finances that helped purchase key baseball players, including the first manager, Clark Griffith. Joseph Gordon was listed as the official president of the organization, but in reality Farrell and Devery ran the club.

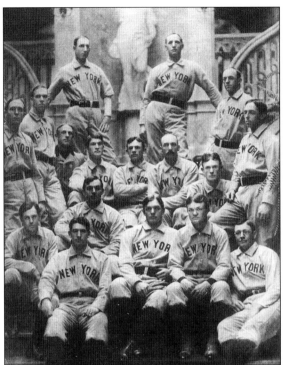

In 1903, the former Baltimore Orioles arrived in New York as the Highlanders. The two rival teams in New York were the Giants, also known as the "darlings of New York," and the Brooklyn Nationals. The Giants were managed by John McGraw, who had left the Baltimore team. This photograph shows the 1903 Giants.

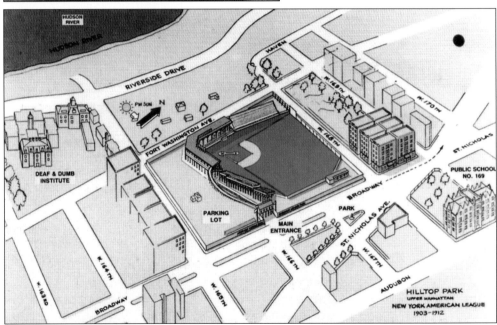

The Highlanders opened their first season at Hilltop Park, otherwise called American League or Highlander Park. The park itself was hastily constructed in six weeks. This map shows the location of Hilltop Park in upper Manhattan, or Washington Heights. Overlooking the Hudson River, it was located on the west side of Broadway between 165th and West 168th Streets. The ballpark was demolished in 1914, and the property was purchased by the Columbia-Presbyterian Medical Center, which still occupies that site today. (Courtesy Marc Okkonen.)

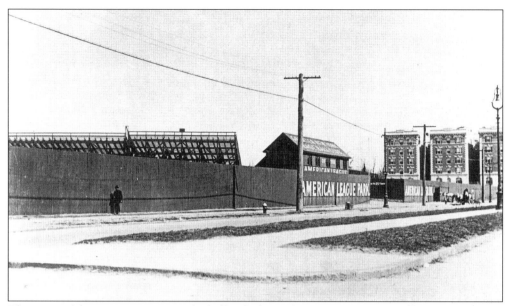

This view of the main entrance to the ballpark shows the corner of 165th Street and Broadway, with the right field bleachers in the background. The lettering on the fence reads, "American League Park."

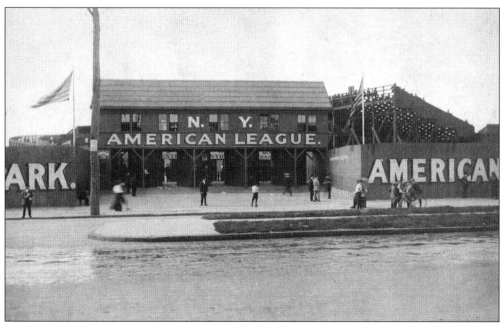

This photograph offers a closer view of the main entrance on Broadway. The second floor was used by the owners and business manager Joe Gavin. The lower level was for ticket purchases and for gaining entrance to the first-base line.

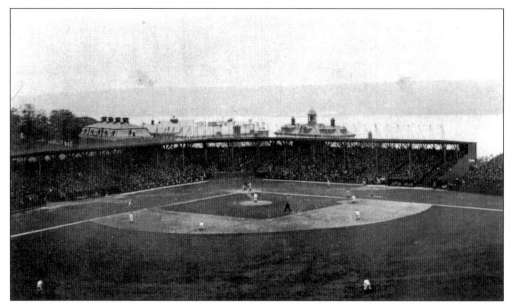

Hilltop Park sat on approximately the highest elevation in Manhattan. Spectators who sat in the top rows behind home plate and along the third-base line could look behind them to enjoy a great view of the Hudson River and the New Jersey Palisades. Looking toward home plate with the Hudson River in the background, this c. 1907 view was probably taken from one of the buildings on 168th Street.

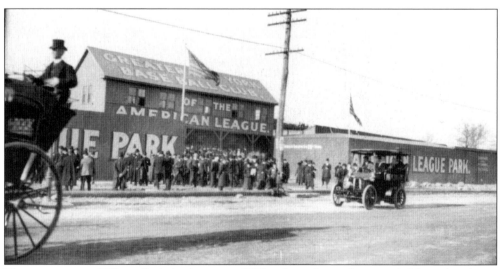

The entrance to Hilltop Park is shown c. 1903, when the park opened. Note that horse carriages were still in use and that going to a ballgame still required the proper dress.

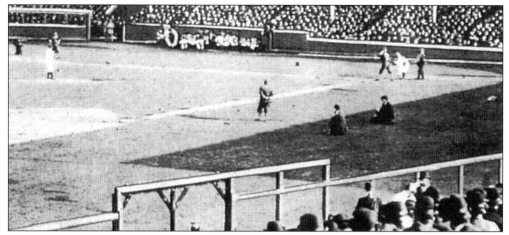

On opening day, April 30, 1903, the Highlanders started their first season at Hilltop Park by beating the Washington Senators 6-2. The stadium was filled to capacity, with more than 16,000 visitors watching the game. Each paying customer was given a small American flag to wave as the 69th Regimental Band played patriotic songs at the opening ceremonies. The construction of the ballpark was not completely finished before the first game. After the game, work continued on the outfield, and a wooden roof was placed over the grandstands.

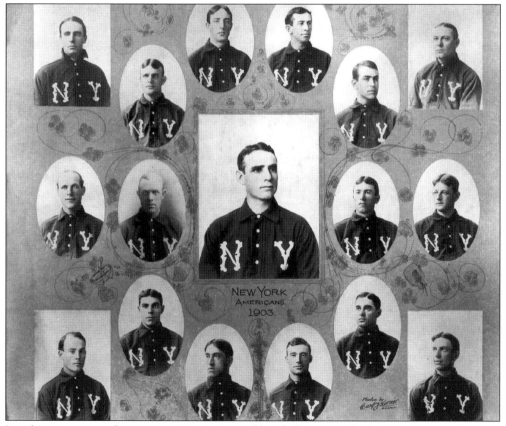

Local newspapers and sports magazines promoted baseball teams and advertisements on the same page. Here, the *Sporting News* promotes the first team composite of the Highlanders in 1903.

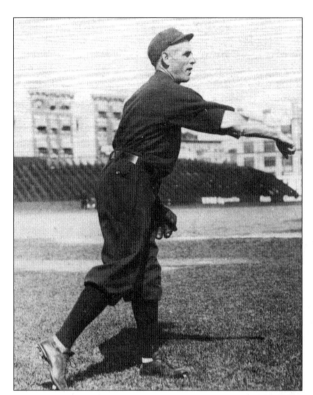

Frank Farrell's financial backing enabled the club to steal Clark Griffith, player-manager for the Chicago White Sox, to manage the Highlanders' opening season. The right-hander, known as "the Old Fox," managed and pitched for the team from 1903 to 1908. Griffith earned a 14-11 pitching record in 1903. He is pictured here warming up before a game at Hilltop Park.

Clark Griffith (born on November 20, 1869, in Clear Creek, Missouri) was the Highlanders' first manager. He managed the team for six years. For the first year, the team took a respectable fourth place. Attendance grew the second year as the Highlanders competed for first place with the Boston Americans. Unfortunately, the Highlanders lost the pennant on the last day of the season, ironically, with their best pitcher, John Chesbro. In later years, Griffith was to own the Washington Senators.

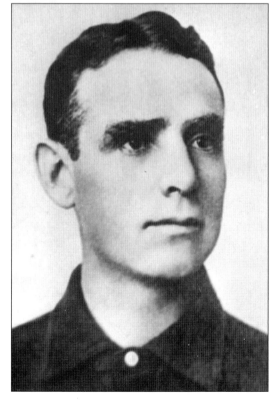

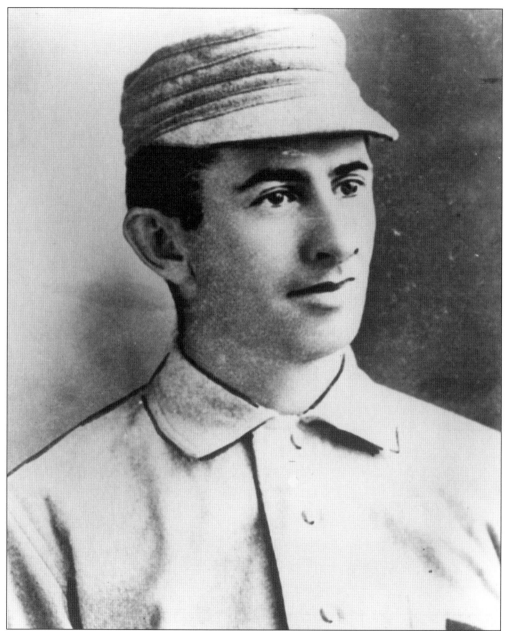

"Wee" Willie Keeler, already a baseball legend before he joined the Highlanders, had been a major player on the 1890s Baltimore Orioles team. Other players on that team were John McGraw, who would become the manager of the New York Giants, and Wilbert Robinson, the manager of the Brooklyn Dodgers. Keeler was given a contract for his drawing power at the gate.

NEW YORK

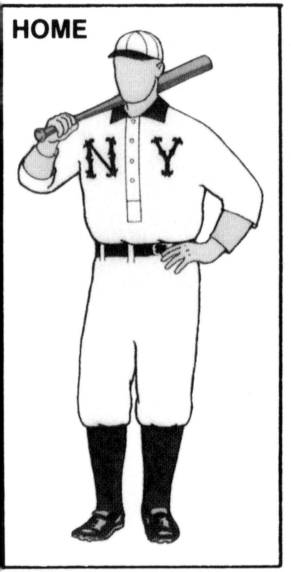
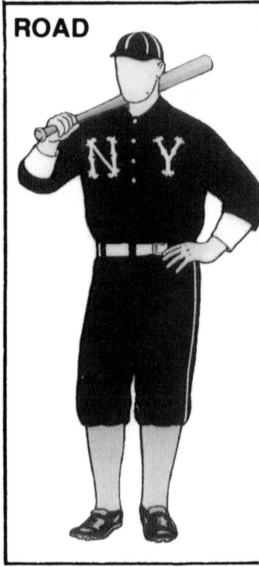

The Highlanders' 1903 uniforms were standard for the time period. The home uniform was white with black letters on the chest and featured a black collar with a four-button shirt. The hat was white with black seams and a black visor. The stockings were solid black. The road uniform was the opposite of the home uniforms. Players dressed in black hats and uniforms, with white stockings. The home uniform was used also in 1904, but the road uniform was changed to a dark blue. (Courtesy Marc Okkonen.)

18

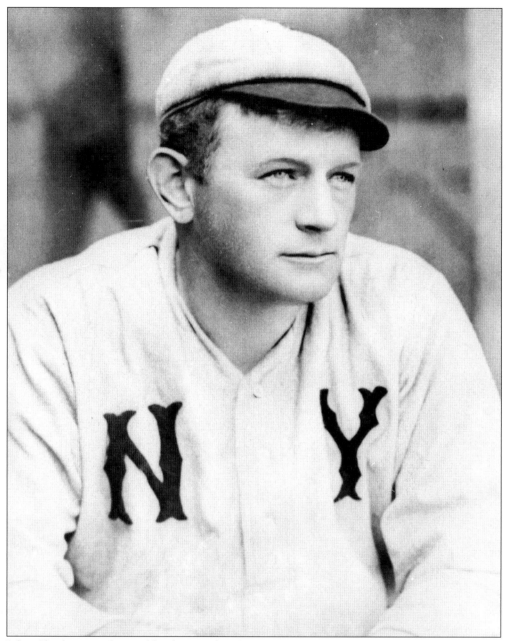

John Chesbro was the Highlanders' pitcher from 1903 to 1909. Nicknamed "Happy Jack," the spitballer posted a 12-15 mark, but it would be his second year that would make baseball history. In 1904, Chesbro started 51 games, completed 48, worked 455 innings, and ended with a 41-12 record (still a modern Major League record). Unfortunately, he is best remembered for one pitch in the last game in the 1904 season for the pennant race.

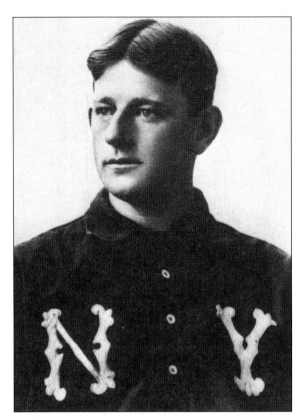

Pitcher John Chesbro climaxed his second history-making year with a heartbreaker. On October 10, 1904, the final game of the season was a doubleheader. The Highlanders were playing the Boston Americans and had to win both games to win the pennant. At the top of the ninth inning, the game was tied 2-2. Boston had a man on third with two outs. Chesbro had two strikes on the batter but lost control of the ball on his next pitch. The ball went over the catcher's head, and the Highlanders went scoreless and lost the game.

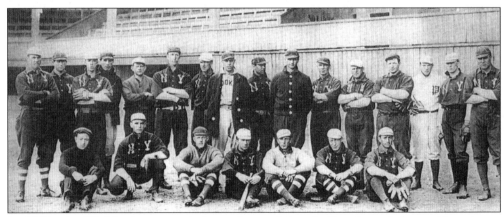

In 1905, the Highlanders moved the spring training facility from Atlanta, Georgia, to Montgomery, Alabama. They would use this site for only one season and choose Birmingham, Alabama, the following year. Most of the players shown here are wearing the 1904 road uniforms. The 1905 uniforms would look drastically different.

The 1906 winter edition of *Sporting Life* magazine featured the Highlanders and their records for the season. This was the first season for a 22-year-old Californian named Hal Chase, who would be the center of controversy a few years later (see page 32). The team placed sixth with a 71-78 record.

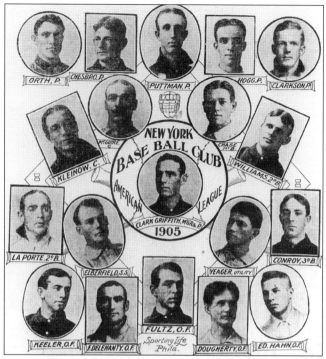

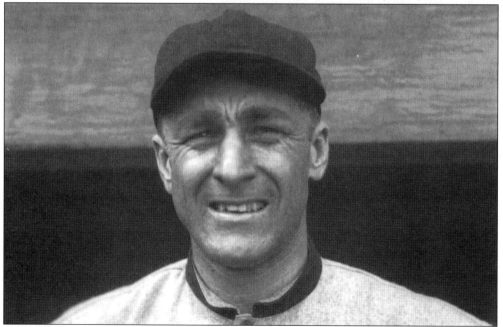

Branch Rickey played with the Highlanders in 1907 as a catcher and outfielder but was traded before the start of the 1908 season. On June 28, 1907, Rickey allowed 13 stolen bases in a 16-5 loss to the Washington Senators. Rickey's fame came from his idea for a farm system and training methods. He started with the St. Louis Browns in 1914 during spring training in St. Petersburg, Florida. Branch is best remembered for integrating baseball with the signing of Jackie Robinson.

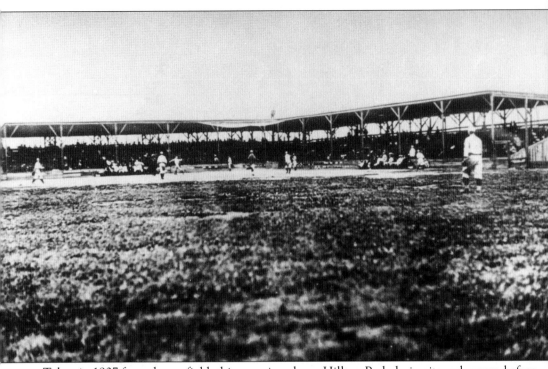

Taken in 1907 from the outfield, this rare view shows Hilltop Park during its early years, before the outfield bleachers were built. It was not uncommon for crowds to sit in the outfield when the game was sold out. There were several games recorded with more than 20,000 fans attending. One playoff game in 1904 listed nearly 30,000 fans, some standing in the outfield. The first-year attendance was 211,808.

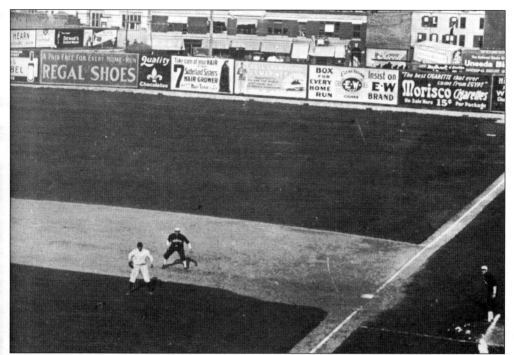

As in many other baseball parks of the time, billboards lined the outfield wall. The typical sponsors of the day included shoe manufacturers, liquor distillers, and tobacco companies. Hilltop Park also included the standard Bull Durham sign in center field. The fence used for these signs was about 15 to 20 feet high.

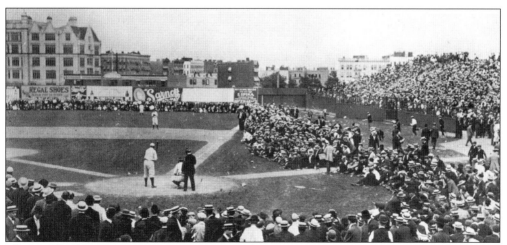

The Highlanders play the Philadelphia Athletics at Hilltop Park on July 4, 1907. The stadium officially listed its seating capacity at 16,000. It was not unusual, however, for crowds to stand along the baselines to watch the game.

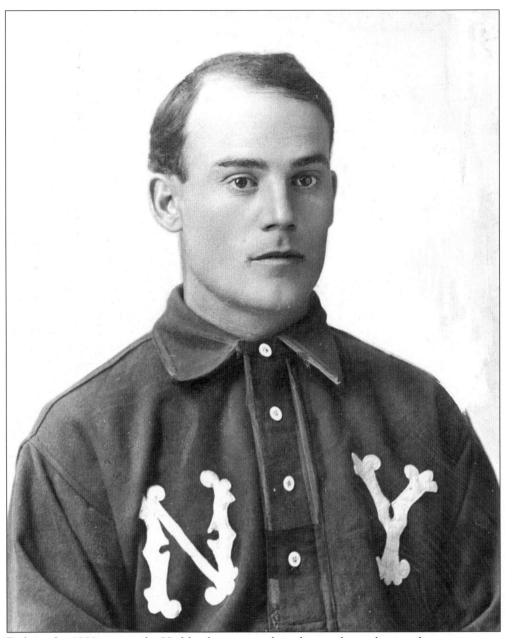

Early in the 1908 season, the Highlanders were in last place and were having the worst season since their inception. The owners replaced Clark Griffith with Norman "Tabasco Kid" Elberfeld, who was the original shortstop for the Highlanders. He led the team to a 27-71 record during his stay as manager. At the end of the season, he was replaced by George Stallings and returned to his position as shortstop until 1909.

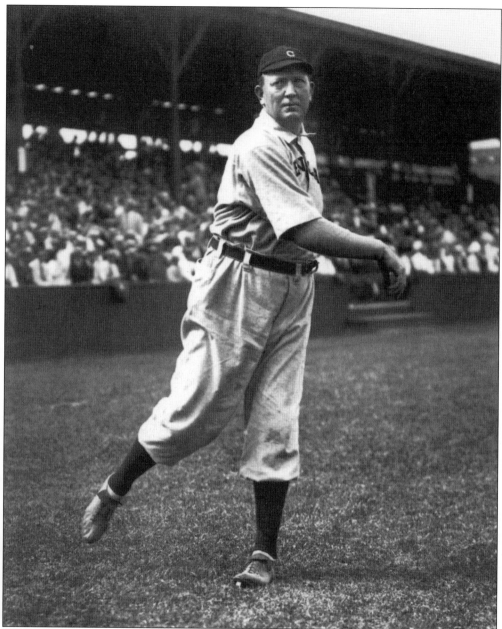

On June 30, 1908, future Hall of Famer Cy Young, at age 41, pitches his third career no-hitter at Hilltop Park. Boston beat the Highlanders 8-0. Young was forced to retire in 1912 due to his weight problem, even though his throwing arm was as good as it was when he first joined the Major League.

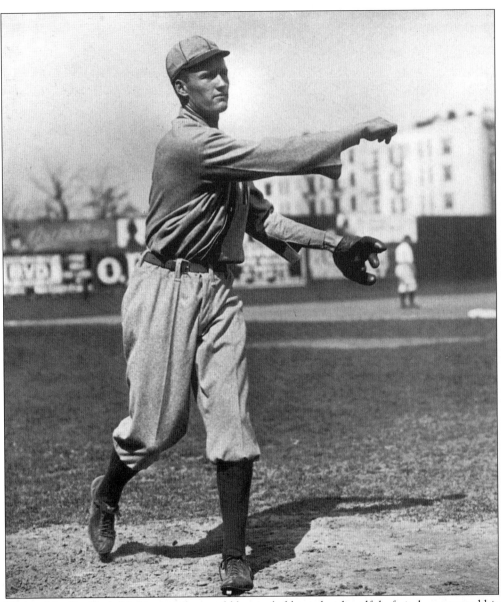
Walter "the Big Train" Johnson, who would be rivaled by only a handful of pitchers, started his 20 years with the Washington Senators in 1907. In 1908, he came to Hilltop and set a record by pitching his third consecutive shutout against the Highlanders in four days. Johnson was one of the first five men to be inducted into the National Baseball Hall of Fame.

In this 1908 view, the Highlanders pose in front of their hotel in Hot Springs, Arkansas, during spring training. Fourth from the right in the back row is a young Branch Rickey. The team had various sites for spring training, including Atlanta, Gray, and Macon, Georgia. Also, games were held in Birmingham, Alabama, and Hot Springs.

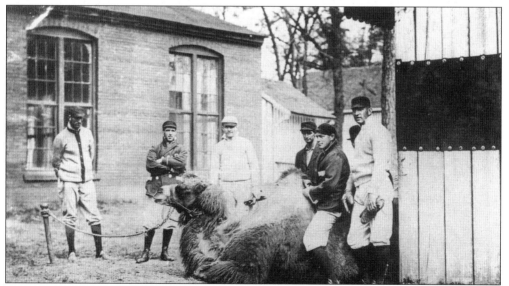

It was strange to see a camel at a spring training site in the south. Perhaps a circus was in town. Either way, players had the same thoughts and had their picture taken next to the camel. The photograph was probably used later for publicity purposes.

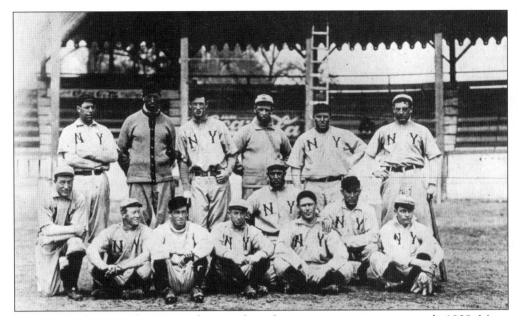

The Highlanders pose for a team photograph at their spring training site in early 1908. Many of the original Highlanders would be gone by the end of the season, including manager Clark Griffith.

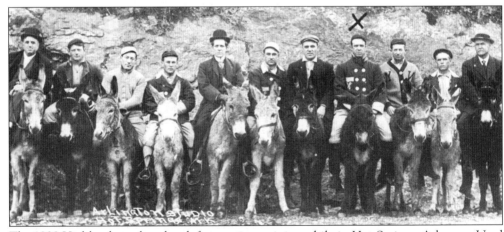

The 1908 Highlanders take a break from spring training while in Hot Springs, Arkansas. Used as a publicity photograph, the view shows the players traveling the trails on donkeys. From left to right are unidentified, John Chesbro, Lou "Red" Kleinow, Norman Elberfeld, unidentified, Jake Stahl, Al Orth, Bill Hogg, Willie Keeler, Clark Griffith, and sportswriter Sam Crane.

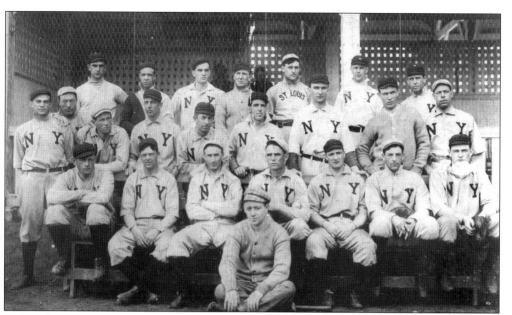

Before the start of the 1908 season, the team poses at spring training in Hot Springs, Arkansas. That season would be the worst in the history of the team.

Sporting Life magazine highlighted the previous season's record for all teams. In the February 13, 1909 edition, the Highlanders posted a 51-103 record. To this day, that many losses remains a record for the Yankees. In midseason, manager Clark Griffith was replaced by Norman "Tabasco Kid" Elberfeld. The team ended the season in eighth place.

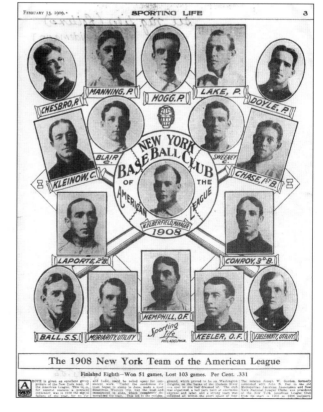

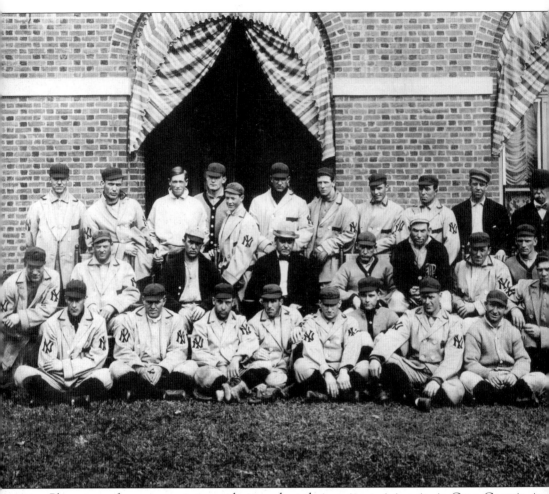

Players pose for a preseason team photograph at their spring training site in Gray, Georgia, in 1909. Their new manager is George Stallings. Notice the players' warm-up-style jackets.

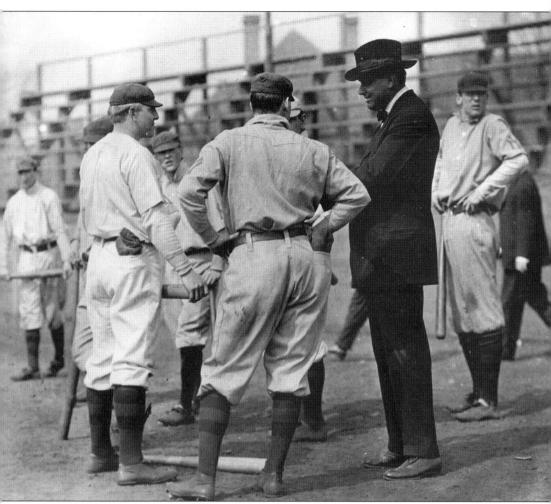

This 1909 photograph shows some of the Highlanders at batting practice after their arrival at Hilltop from spring training in Georgia. Co-owner Frank Farrell talks with some of the players. Note the interlocked NY on the players' sleeves. It was the first time that logo was used by the Highlanders.

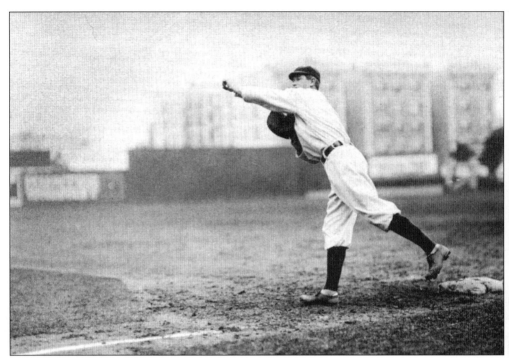

Hal Chase, who played for the Highlanders from 1909 to 1913, is considered to be one of the best fielding first basemen. He was the team's captain and served as manager for the 1910–1911 season. He was a left-handed thrower and a right-handed batter—a rare combination. Despite his talents, many considered him to be the most distrusted man in baseball. He was constantly accused of winning bets with inside information on fixed games. Eventually, he was released by manager Frank Chase for his questionable performance on the field.

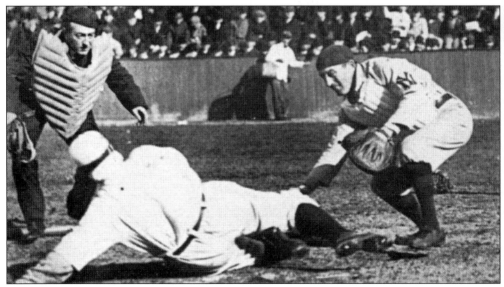

This c. 1909 action shot shows a Highlanders catcher (possibly Jeff "Ed" Sweeney) tagging out a Boston Red Sox player at Boston's ballpark.

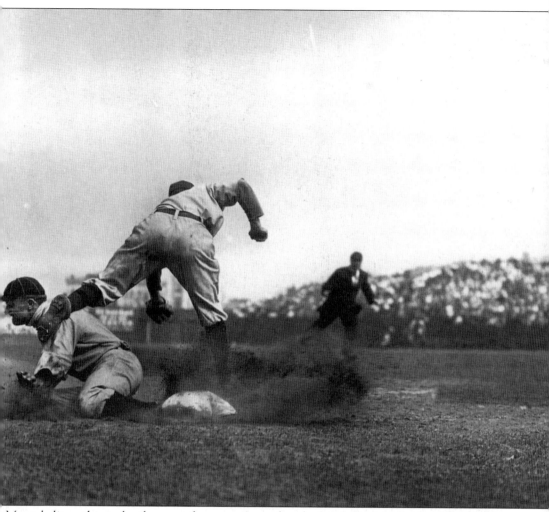

Many believe this to be the most famous image taken by baseball photographer Charles M. Conlon. In a 1909 game between the Highlanders and the Detroit Tigers, the notorious Ty Cobb sent the third baseman Jimmy Austin face first into the dirt. Luckily, Cobb's sharpened spikes did not hurt Austin.

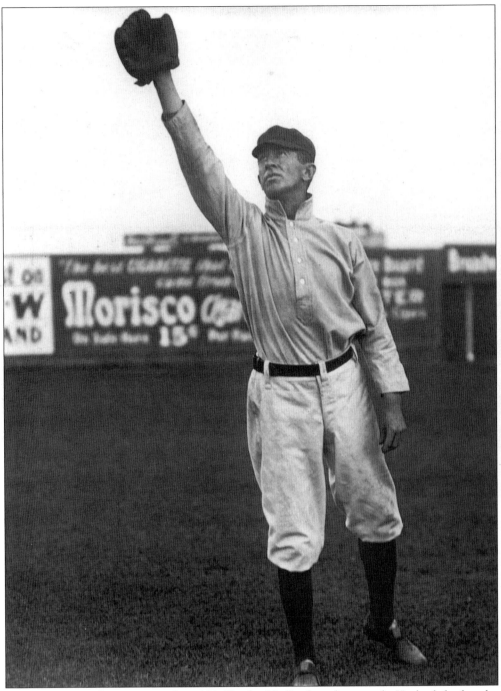

"Wee" Willie Keeler is seen in this 1909 Charles M. Conlon photograph. Keeler left after the 1909 season. He ended his career with the New York Giants and his old pal and manager, John McGraw.

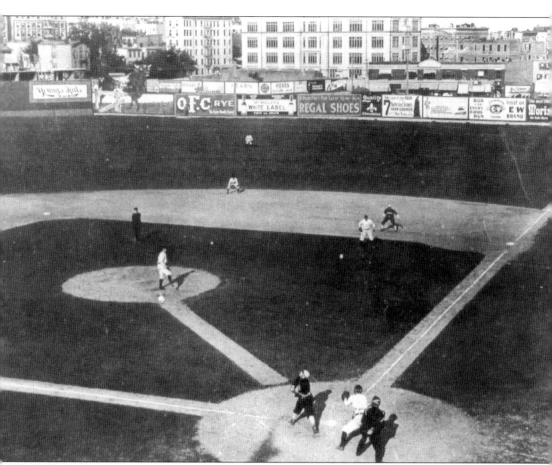

This rare action photograph shows a game at Hilltop Park between the Highlanders and the Chicago White Sox in 1909. That year, the Highlanders first used the now familiar interlocked NY logo on the team's hat and on the left sleeve.

George Stallings was the Highlanders' manager for the 1909 season. On September 23, 1910, he was forced to resign amid controversy over first baseman Hal Chase. Ironically, Chase became manager after Stallings resigned, and the team took second place—the best they had done since 1906.

Jack Warhop, also on the tobacco card on the facing page, spent his career with the Highlanders from 1908 to 1915. He pitched a total of 162 games with a .426 average. His best years were 1910 and 1911; he was 14-14 and 13-13, respectively.

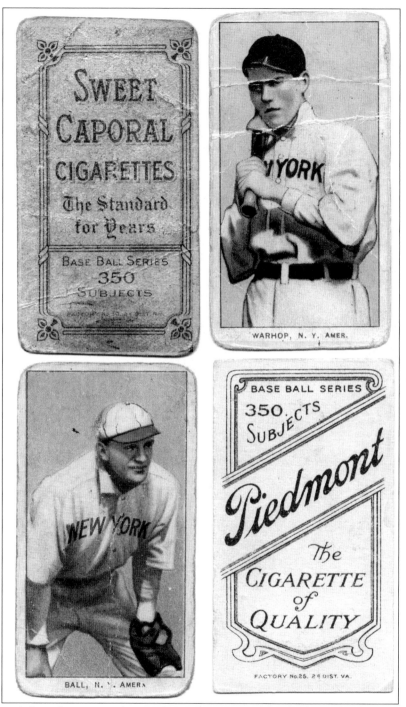

Baseball cards have been around since the mid-1880s. Unlike the baseball cards of today, the cards were sponsored by cigarette companies. The tobacco cards were packaged with various brands of cigarettes as a collectible keepsake. In 1909, the American distributor produced these cards, now known to collectors as the T-206 series. The two Highlander players shown are Jack Warhop and Neal Ball.

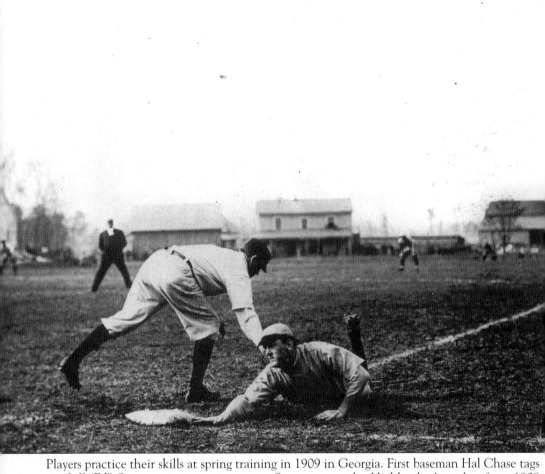

Players practice their skills at spring training in 1909 in Georgia. First baseman Hal Chase tags out Jeff "Ed" Sweeney in a practice game. Sweeney was the Highlanders' catcher from 1908 to 1915.

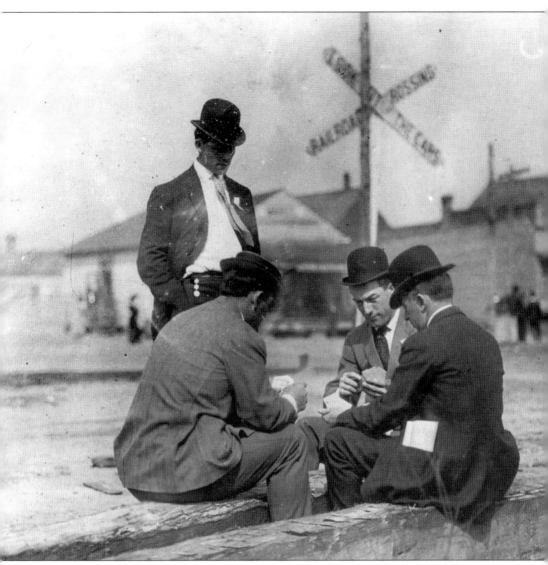

Players would fight off the boredom of waiting for trains by playing cards or reading the paper. In this view, some of the 1909 team members play a round of cards next to the railroad tracks at their spring training site in Gray, Georgia.

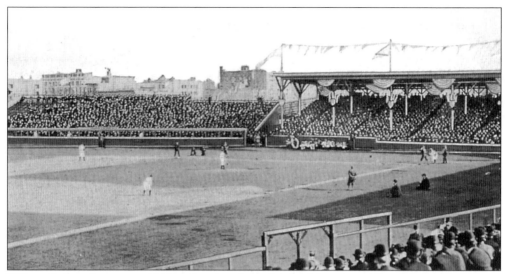

Hilltop Park is shown in a 1910 view taken from the third-base line. The seating capacity was said to be more than 16,000. In 1911, a roof was added over the stands down the left field foul line.

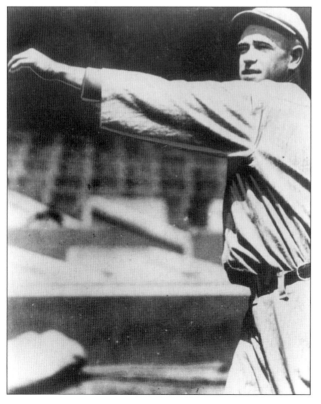

Even with all the controversy surrounding his conduct with gambling, Hal Chase was made manager in 1910 after George Stallings was fired for not firing Chase. The owners felt that Chase would be more respectable as a manager, but that did not work out. Chase remained the manager until Harry Woverton was hired for the 1912 season. Hal was eventually released in 1913 by manager Frank Chance, who refused to put up with his antics.

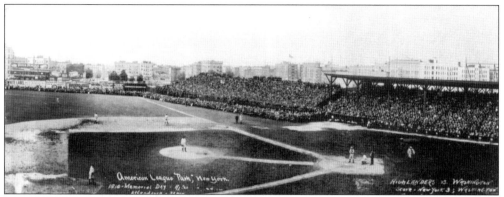

This photograph shows the entire scope of Hilltop Park on Memorial Day 1910 from the third-base line. Such panoramic views were popular in the early 1900s.

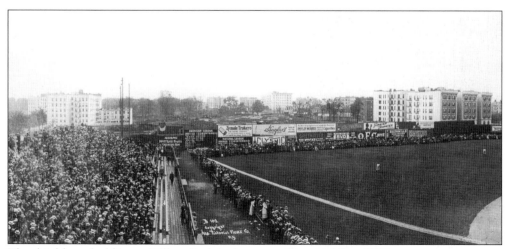

The third-base foul line at Hilltop Park is shown on Memorial Day 1910.

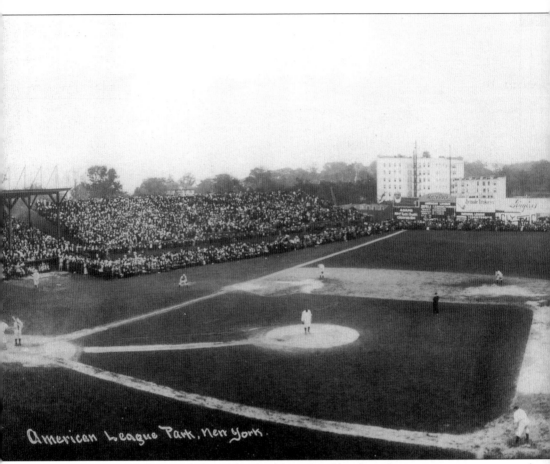

American League Park, New York.

This rare view of Hilltop Park shows the third-base-line bleachers. It was common to see crowds standing in the outfield next to the advertising signs at sold-out games. Outfield bleachers were installed in 1912, the last season the Highlanders played at Hilltop. This photograph was probably taken on Memorial Day 1910.

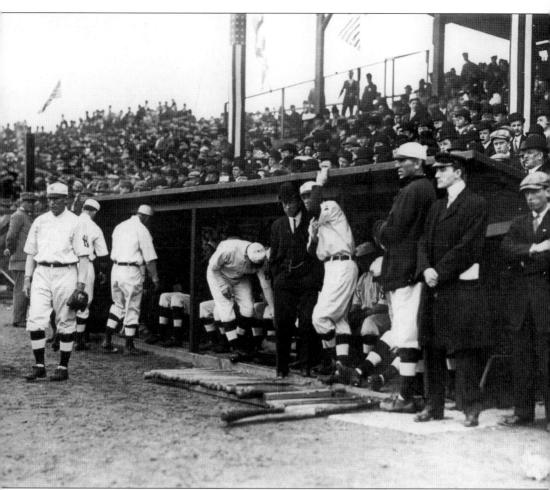

The Highlanders' dugout is shown during the 1911 opening at Hilltop Park.

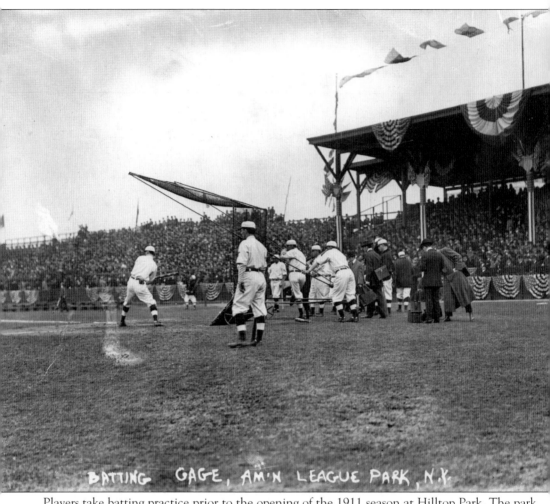

BATTING GAGE, AM'N LEAGUE PARK, N.Y.

Players take batting practice prior to the opening of the 1911 season at Hilltop Park. The park is decorated with American flags and bunting throughout the stands and field area. Note the photographers and reporters taking pictures for the newspapers. The players' sock pattern and hat are a visible way of showing it is 1911.

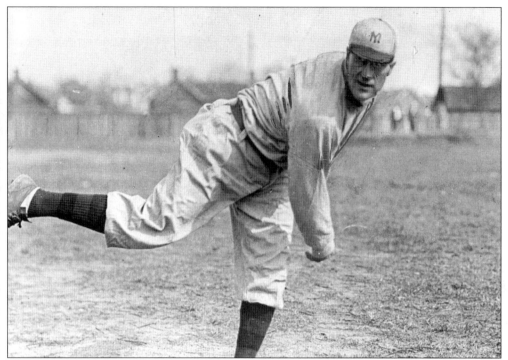

Photographed in 1911 during spring training, Roy Hartzell played many positions for the Highlanders and Yankees from 1911 to 1916. Within six years of his stay with the team, he covered second base, shortstop, third base, and the outfield.

On April 14, 1911, crosstown rivals New York Giants lost the Polo Grounds to a devastating fire. The Highlanders invited the Giants to share Hilltop Park with them. By the end of June, the Giants were able to return to the Polo Grounds and play, even though the construction was still not completed. Ironically, two years later, the Highlanders would take up an offer by the Giants to use the field while the Yankees looked for a new location to build a stadium since Hilltop Park had become unusable. The Yankees' stay at the Polo Grounds would last 10 years.

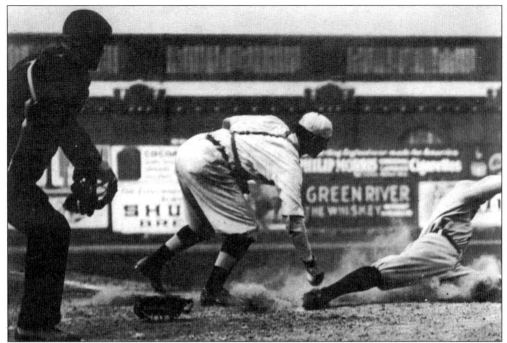

In a 1911 game between the Highlanders and the Boston Red Sox, Tris Speaker slides safely home under the tag of catcher Walter Blair. Blair was a catcher for the Highlanders from 1907 to 1911.

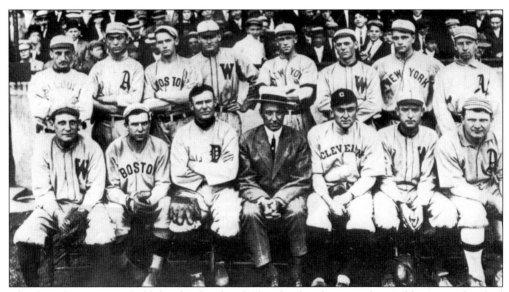

This benefit game was held for the family of Cleveland Indians pitcher Addie Joss, who died from a lung disease in 1911. An American League all-star team was assembled for the event. Members of the team included Ty Cobb (front row, fifth from left), "Smokey" Joe Wood (back row, third from left), Hal Chase (back row, fifth from left), and Russ Ford (back row, seventh from left). Ford's 1910 rookie year was impressive with a 26-6 record, but he never again gained those statistics and was gone by 1914.

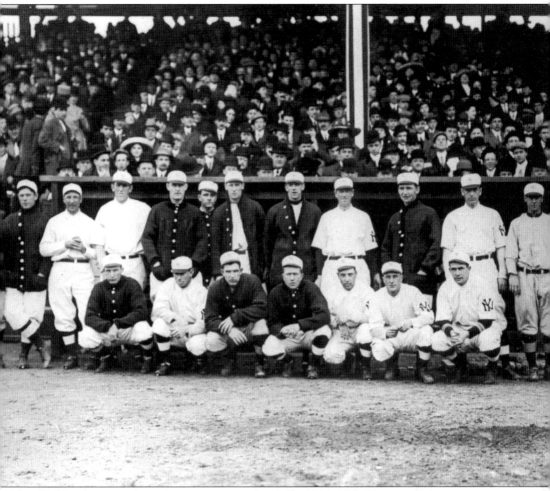

The Highlanders pose for a team picture on April 22, 1911. Hal Chase was player-manager. Sportswriters and players were questioning his ethics of possibly throwing games for bets. The Highlanders would take sixth place with a 76-76 win-loss record. The season would also be the first time the Highlanders used the "New York" on the front of their gray road uniforms.

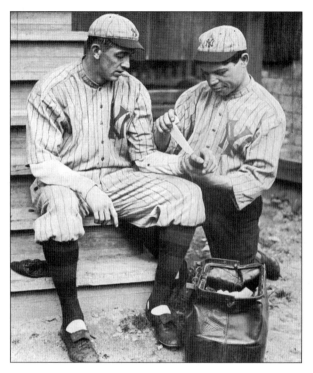

Ray Caldwell, a right-handed pitcher for the Highlanders, started in 1910 and played with the team until 1916. His best season with the team was 1914, with a 17-9 record. Here, Caldwell is being taped up by a team assistant at the spring training camp in Macon, Georgia, for the 1912 season.

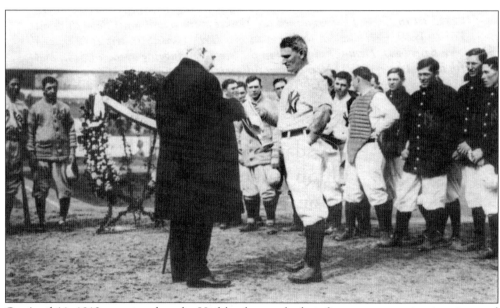

On April 11, 1912, opening day, the Highlanders made their first appearance in pinstripes and interlocked *NY* logo, which has become their trademark uniform. The team would again change the appearance of their uniforms in 1913 and not return to pinstripes until 1915. The interlocked *NY* logo would again disappear on the home uniform and not return until 1936. In the foreground of this photograph are co-owner Bill Devery (left) and new manager Harry Wolverton at the opening celebration.

In 1912, the team hired a new manager, Harry Wolverton. It turned out to be a poor choice. The team had a 50-102 record and finished last. At the end of the season, Wolverton was fired.

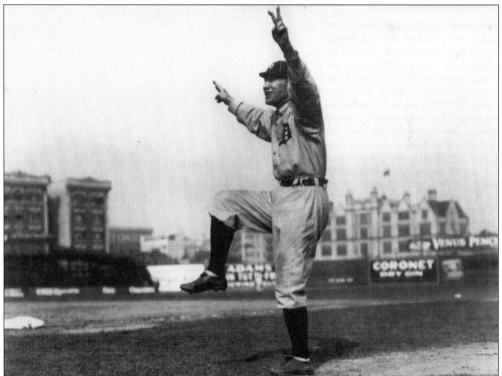

Detroit manager Hughie Jennings was always expressive with his signals. Here he calls the signs from the first-base line at Hilltop Park in 1912. Jennings was captain of the Baltimore Orioles and was teammates with Willie Keeler, John McGraw, Wilbert Robinson, and Kid Gleason.

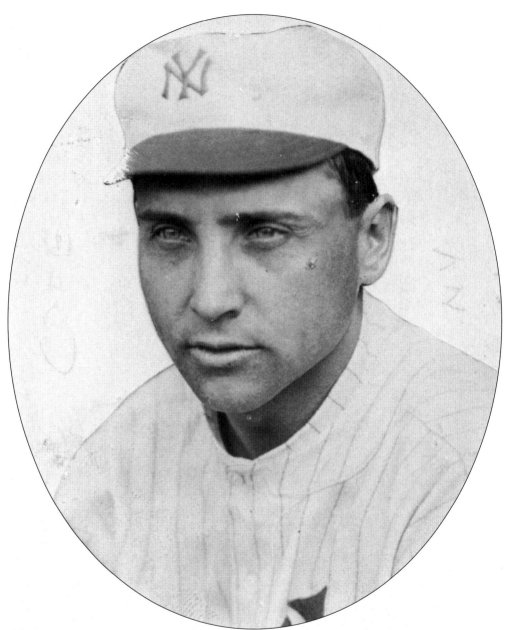

William "Birdie" Cree started his career with the Highlanders in 1908 and continued playing outfield until 1915. In 1911, Cree and Hal Chase became the first teammates in Major League history to steal four bases each in a game. Cree finished third in steals that same season, with 48. Cobb led with 83. Birdie also hit the first official grand-slam home run as a Yankee after the team name changed in 1913. Some think that present-day Yankee shortstop Derek Jeter bears an uncanny resemblance to Cree.

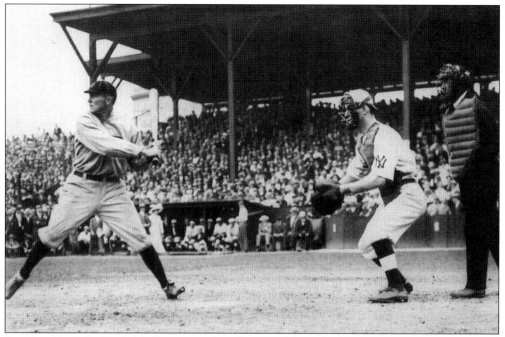

On May 15, 1912, Ty Cobb (batting in this photograph) was walking into the dugout at Hilltop Park when a spectator yelled a racial slur at him. Furious, Cobb jumped the railing and attacked the fan, brutally beating him. The spectator, Claude Lueker, had lost both hands in an accident and could not defend himself. Cobb was banned from baseball but, with team support, the ban was dropped. Instead, Cobb was fined $50 and received a 10-day suspension.

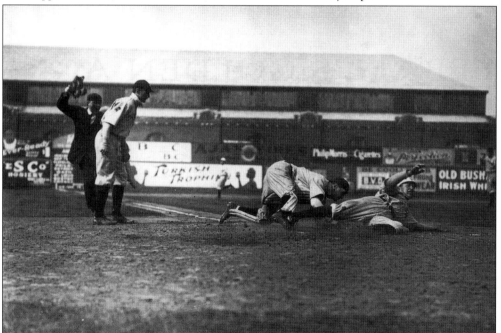

At Hilltop Park on May 18, 1912, Highlander outfielder Bert Daniels has just been thrown out at home by Cleveland center fielder "Shoeless Joe" Jackson. The catcher is Ted Easterly.

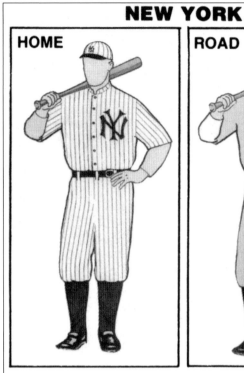

NEW YORK

HOME

ROAD

In 1912, the club altered the uniform to include pinstripes and the interlocked *NY*. This was the first time the now traditional uniform was used. The appearance of this style was short-lived. It reappeared in 1915 and was then modified. It finally reappeared in its familiar form in 1936 and continues to be the style. (Courtesy Marc Okkonen.)

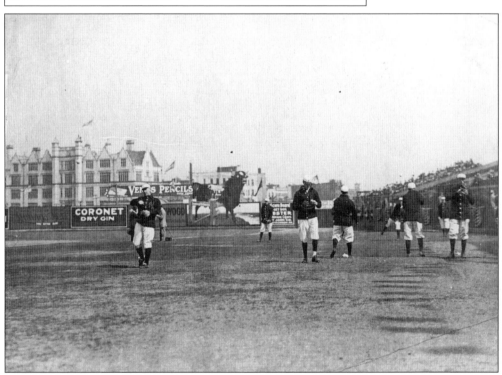

Members of the Highlander team in 1912 take warm-up throws prior to their game. Note the Bull Durham sign, which was placed in many ballparks around the United States.

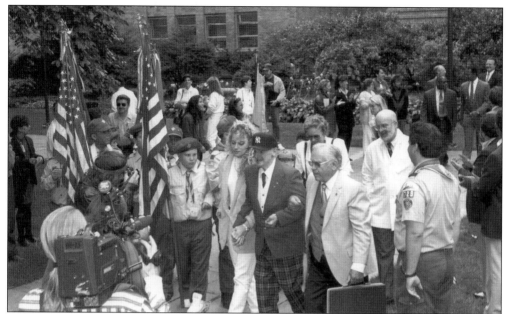

In September 1993, the Presbyterian Hospital of New York (Columbia-Presbyterian Medical Center) dedicated a plaque commemorating the original location of Hilltop Park. In honor of the event, Yankees general manager Gene Michael and assistant general manager Willie Randolph attended. The guest of honor, 102-year-old Chester Hoff, was the oldest former Major League player alive. Hoff, a left-hander, pitched for the Highlanders from 1911 to 1913. (Photograph by Joan Penn.)

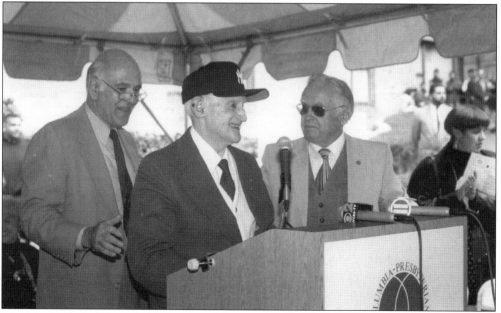

Chester Hoff speaks at the dedication. The event marked the 90th anniversary of the first baseball season at Hilltop Park. Hoff's experience as a rookie pitcher included striking out Ty Cobb as a reliever for Russ Ford. The Yankees lost that game to the Detroit Tigers 9-4. (Photograph by Joan Penn.)

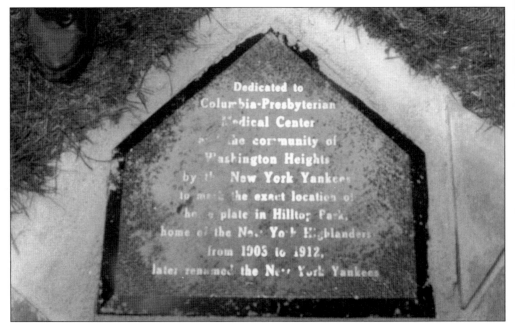

Dedicated to
Columbia-Presbyterian
Medical Center
and the community of
Washington Heights
by the New York Yankees
to mark the exact location of
home plate in Hilltop Park,
home of the New York Highlanders
from 1905 to 1912,
later renamed the New York Yankees

When all the speeches were delivered, the plaque was unveiled by umpire Frank Vacarelli. The plaque, in the shape of home base, is in the exact location of the original home plate at Hilltop Park. The plaque gives a concise history of Hilltop Park. (Photograph by Joan Penn.)

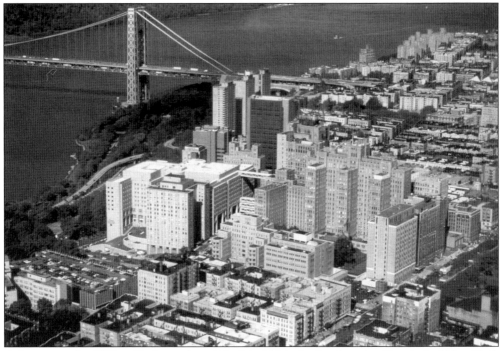

A few years after Hilltop Park was demolished in 1914, the Presbyterian Hospital of New York began construction along 168th Street and Broadway. Over the years, the hospital expanded its facilities, and the Columbia-Presbyterian Medical Center complex now includes more than a dozen structures. This aerial view shows the present-day medical center.

Two

THE YANKEES
(1913–1920)

By the end of the 1912 season, the lease had expired for Hilltop Park. The owners felt that it was not worth the investment to revitalize the stadium, so they accepted a generous offer from the New York Giants to share the Polo Grounds. The Yankees would remain there for 10 years. Here the team poses in their new surroundings before the 1913 season. Note that not all of the players have started wearing the 1913 uniforms; some players are still wearing the 1912 style.

The Yankees shared the Polo Grounds with the New York Giants between 1913 and 1923. In 1913, the Giants were New York's winning team, already world champions several times. John McGraw never considered the Yankees a threat and allowed the team to stay. McGraw did, however, make sure the Yankees never got the same respect as the Giants did with the crowds. The Yankees' status would change by the 1920s. Pictured here are the 1913 National League champions awaiting the arrival of the Yankees at the Polo Grounds.

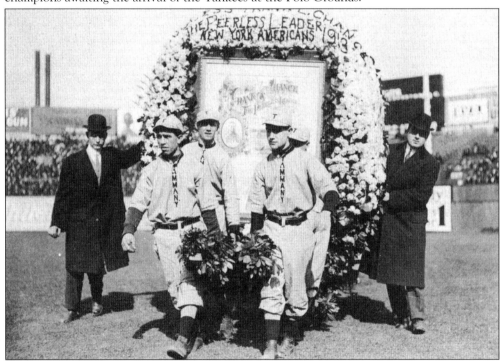

In April 1913, at the Polo Grounds, Frank Chance is given a warm welcome as manager of the newly christened Yankees. Chance, nicknamed "the Peerless Leader," was a former player for Chicago and part of the great trio of Tinker, Evers, and Chance. In this view, members of Tammany Hall, the political powerhouse in New York City, dress in baseball uniforms.

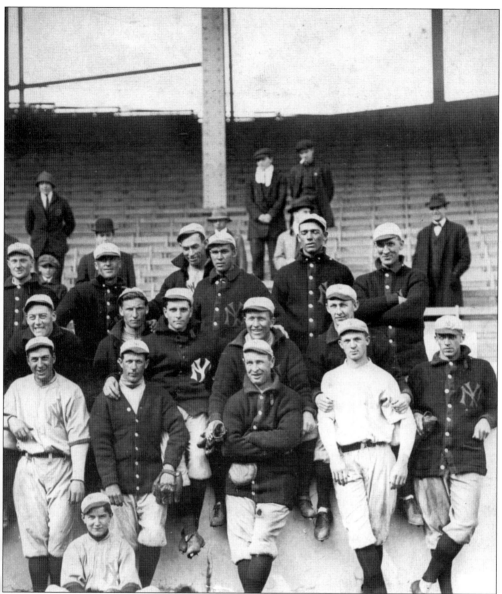

The 1913 season's only contribution to Yankees history was that the team would now be officially recognized as the New York Yankees. On April 10, 1913, opening day in Washington, the team used the new name, but it did not change their luck. More than 45 different players wore the Yankee uniform in 1913. This photograph of the team was taken on April 4, 1913, six days before the season began.

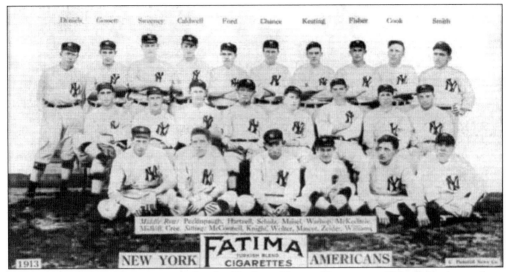

Although 1913 was a losing season for the Yankees, Fatima Cigarettes still had them pose for a team picture advertisement. As with trading cards, the cigarette companies were using baseball players to advertise their product. Frank Chance (back row, sixth from left) started his first year as manager of the team.

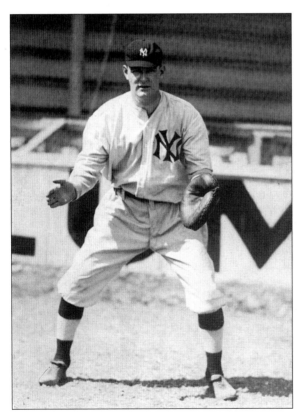

Jeff "Ed" Sweeney was the Yankees' catcher from 1908 to 1915. He holds the distinction of being the only player on the 1913 club to play the same position for the entire season. His best year was 1912, when he hit .268. This photograph shows an excellent detail of the 1913 game uniform. Note that the interlocked NY is there, but no pinstripes.

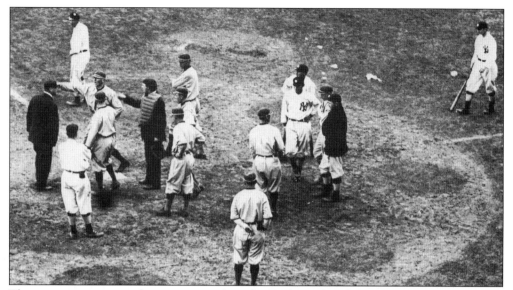

This rare scene was caught on camera when the Yankees played the Washington Senators in April 1913. Senators pitcher Walter Johnson disagrees with the third-base umpire on a call. At the same time, the Senators' manager Clark Griffith discusses the problem with the home-plate umpire. Yankee teammates gather to listen to the results.

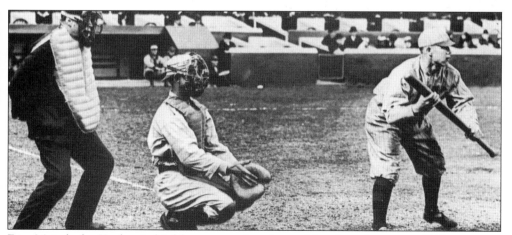

Fritz Maisel, the Yankees' third baseman, takes the position for a bunt in a 1913 preseason exhibition game between the Yankees and the Boston Braves. Maisel played for the Yankees until 1917.

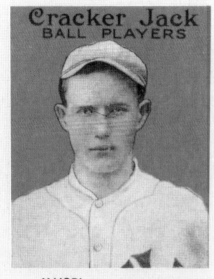

MAISEL, New York - Americans

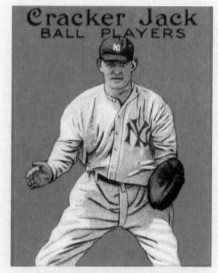

SWEENEY, New York - Americans

KEATING, New York - Americans

PECKINPAUGH, New York - Americans

One of the favorite concession snacks at the baseball park was Cracker Jacks. In 1914, the Cracker Jacks Company put out a set of baseball cards; one card was included in every box. While eating their Cracker Jacks, kids would hope to pull out a card of their favorite player. This photograph shows some of the Yankees who were on the team at that time.

Roger Peckinpaugh, the Yankees' shortstop, was obtained from Cleveland and played from 1913 to 1921. He was also the youngest manager in Yankees history. At age 23, and only in his second year of Major League baseball, he managed the team for 20 games in 1914 after Frank Chance resigned. This photograph is from 1920.

The 1914 season for the Yankees was a disappointment. The team finished sixth, attendance was down, and manager Frank Chance was replaced by Roger Peckinpaugh. The only redeeming point of the season was that third baseman Fritz Maisel, seen in this photograph, had 74 stolen bases.

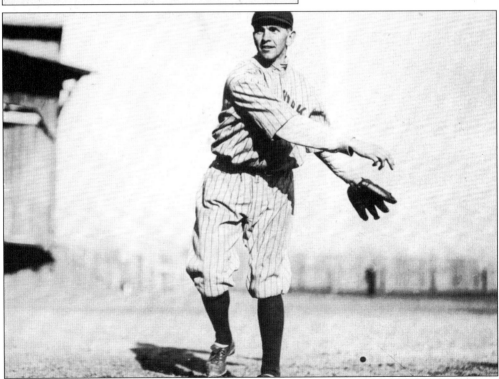

Right-handed pitcher Bob Shawkey, from the Philadelphia Athletics, was purchased by the Yankees in 1915. Within a couple of years, Shawkey was the team's best pitcher. Shawkey stayed with the Yankees until 1927 and became a four-time 20-game winner.

By 1915, Yankee owners Bill Devery and Frank Farrell, who were not on speaking terms with each other, were interested in selling the team. They were contacted by two prospective buyers named Jacob Ruppert and Tillinghast L'Hommedieu Huston, who were friends with New York Giants manager John McGraw. On January 11, 1915, the club was sold to the new partners for $460,000. New partner Jacob Ruppert is seen in this photograph.

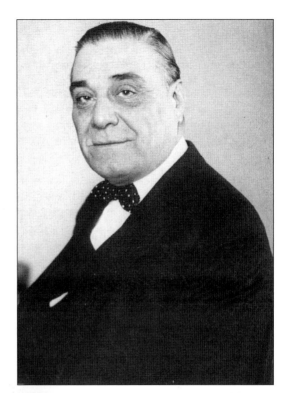

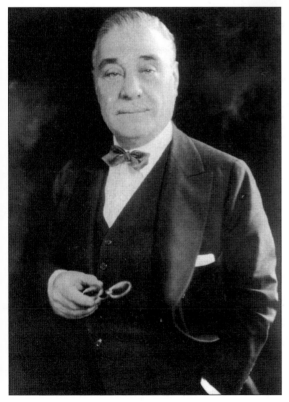

Jacob Ruppert was an honorary colonel in the New York National Guard, a four-term congressman, and heir to the Ruppert Brewery. It was Ruppert's money that allowed the club to buy players' contracts, such as Babe Ruth, Sam Jones, and other players in the next few years. Ruppert would maintain ownership of the Yankees until he passed away at age 71, on January 13, 1939. It was Ruppert's suggestion to have pinstriped uniforms during the 1915 season.

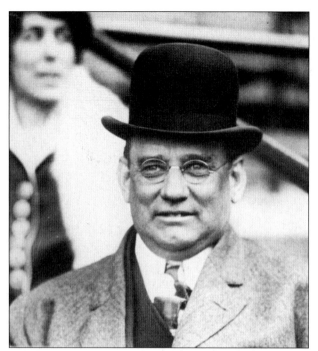

Col. Tillinghast L'Hommedieu Huston was co-owner of the Yankees with partner Jacob Ruppert. Huston was a self-made millionaire who made his fortune in the harbor-improvement business in Cuba. He served as a colonel in the army during World War I while Ruppert took control of the Yankees. Ruppert's hiring of Miller Huggins while Huston was in France would cause the eventual split of the partnership.

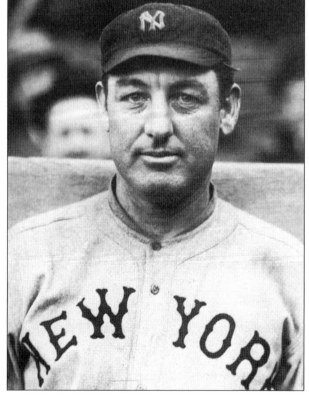

"Wild Bill" Donovan, a 39-year-old right-handed pitcher from the Detroit Tigers, served as the Yankees' manager from 1915 to 1917. His best team placing was a fourth place in 1916. With a sixth-place finish in 1917, the owners replaced him with a new manager.

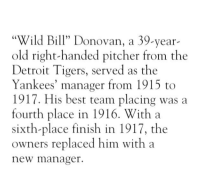

Wally Pipp played for the Yankees from 1915 to 1925. He was acquired from the Tigers for $7,500. His contribution to the team included leading the majors in home runs in 1916 and 1917, as well as being a solid first baseman. His claim to Yankee history would come in 1925, when he was succeeded at first base by Lou Gehrig due to a batting practice accident.

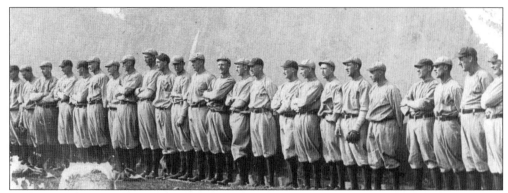

The Yankees pose c. 1916. The photograph is hard to date, as there are so many different types of uniforms and equipment being used by the players. It can only be assumed that it was a practice game.

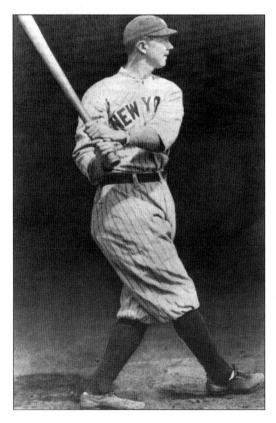

In 1916, the Yankees lured J. Franklin "Home Run" Baker back into baseball. He had retired at age 28 from the Philadelphia Athletics. The Yankees bought out the remaining Athletics contract for $35,000, and Baker returned and proved to be a huge draw at the gate. Unfortunately, Baker hurt himself midseason and missed 50 games. He would stay with the Yankees until 1921.

Co-owner Tillinghast L'Hommedieu Huston, a war veteran, used his army background to influence the team. During the 1917 spring training season in Macon, Georgia, Huston brought in army drill sergeants to teach marching drills to the players. Huston's philosophy was that it would help the players physically and promote patriotic spirit for America's entrance to World War I.

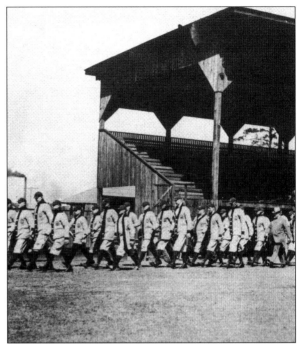

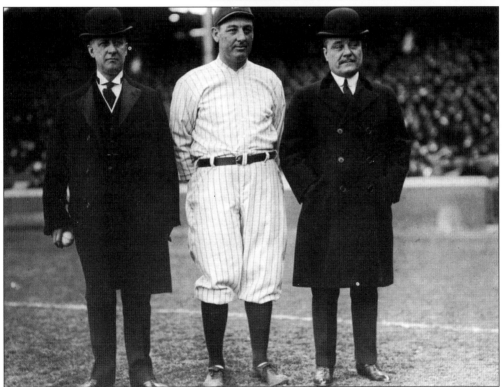

Jacob Ruppert (right), one of the co-owners of the Yankees, stands next to manager Bill Donovan (center) and city sheriff Al Smith, who would be the future governor and democratic presidential candidate. This photograph was taken in 1917.

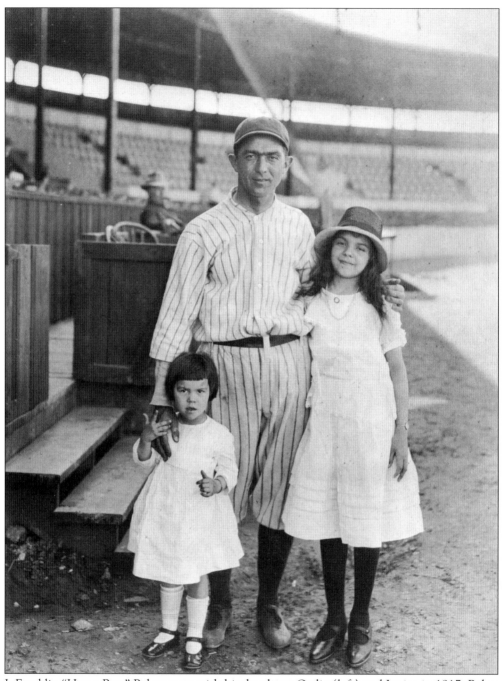

J. Franklin "Home Run" Baker poses with his daughters Ottlie (left) and Janice in 1917. Baker led the Yankees club with 10 home runs in 1918.

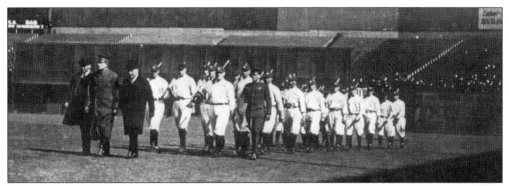

Most baseball teams showed a great deal of patriotism during World War I. Ban Johnson made it official policy in 1918 that the teams practice military drills. Patriotic songs such as George Cohan's "Over There" were played by live bands, and flags were distributed to the crowd. Here the Yankees team members display an organized marching routine during an inning break in 1918.

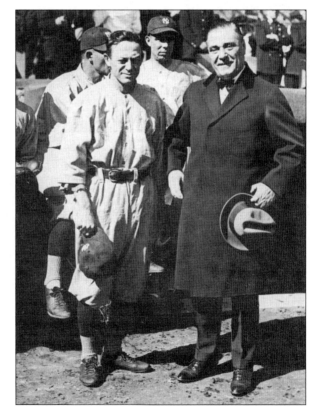

Yankees manager Miller Huggins (left) and Jacob Ruppert stand near the dugout for opening-day ceremonies on April 15, 1918, at National Park, Washington. Miller was given a two-year contract. Ruppert's partner, Tillinghast L'Hommedieu Huston, who had gone to war and was stationed in France, was furious with the contract, and it eventually led to Huston selling off his investment in the team. The Yankees won the season opener 6-3.

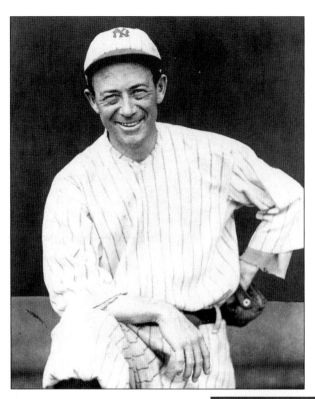

Miller Huggins was the ninth manager in the Yankees' history. Many sportswriters were surprised at Ruppert's decision, but with the suggestion by Ban Johnson, Ruppert originally signed Huggins to a two-year contract. Prior to his arrival as Yankee manager, Huggins had led the St. Louis Cardinals to a 346-415 record in the previous five years. Tillinghast L'Hommedieu Huston disagreed with the choice and eventually sold his part of the partnership to Ruppert. Huggins would be the Yankees manager until September 25, 1929, when he unexpectedly died. He was the first great manager in Yankee history.

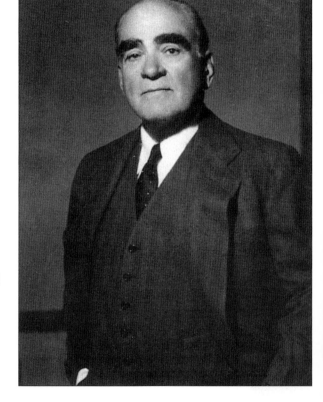

Ed Barrow, originally with the Red Sox, was enticed by Ruppert to become the Yankees' general manager on October 29, 1920. Barrow would be an integral part of the Yankees' organization for many years, winning 14 pennants and 10 World Series.

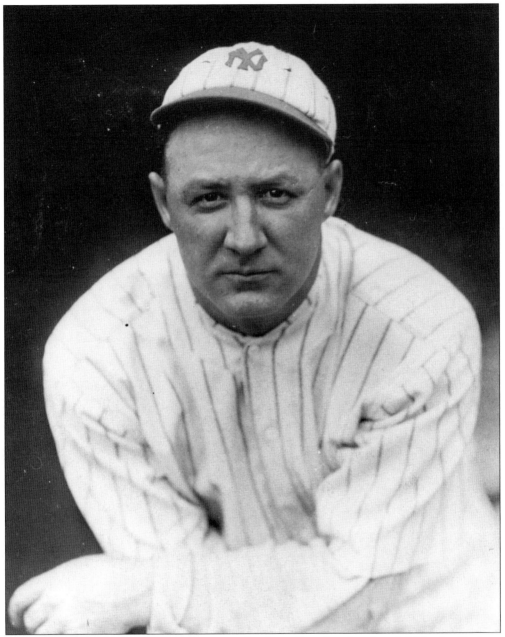

"Ping" Bodie, whose real name was Francesco Stephano Pezzolo, played outfield for the Yankees from 1918 to 1921. Ping batted .295 in 1920. His claim to Yankee fame was being Babe Ruth's first-year roommate. He was often quoted as saying, "I don't room with Babe Ruth; I room with his suitcase."

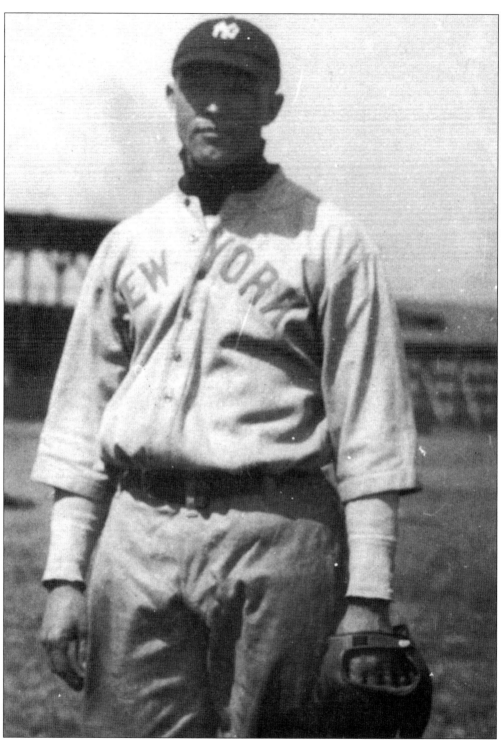

Sammy Vick played outfield for the Yankees from 1917 to 1920. He was relieved from his position when the Yankees acquired a new outfielder from Boston, Babe Ruth. Vick was traded to Boston for the 1921 season and left baseball a year later.

Three

BABE RUTH COMES TO THE YANKEES

George Herman "Babe" Ruth (back row, far left) was born in Baltimore, Maryland, in 1895. By the time he was seven, he was placed in St. Mary's Industrial School for Boys. Because of his behavioral problems, he would stay there until he was 16. During his stay at the school, he learned and excelled in the game of baseball, which was taught to him by school prefect Brother Matthais. Ruth joined the Baltimore Orioles and, in 1914, was purchased by the Red Sox.

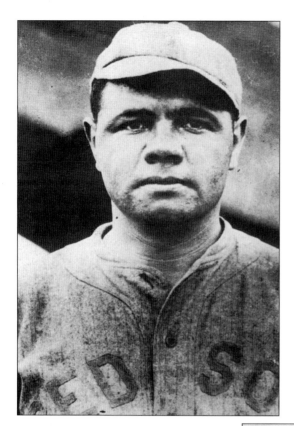

Before arriving in New York, Babe Ruth had already reached star status in Boston. In 1919, his last year in Boston, he had batted .322 and set a new Major League home run record of 29. Prior to his change to the outfield, he was an outstanding pitcher. The Yankees were ready for their new star.

On December 26, 1919, the Yankees signed a contract for their new player, Babe Ruth. Harry Frazer (seen in this photograph), owner of the Boston Red Sox, had financial difficulties with his broadway shows and needed cash, so he decided to sell Ruth's contract. Ruppert paid more than $100,000 outright and loaned him $350,000, with Fenway Park as security. The Boston fans would never forgive Frazer for that trade.

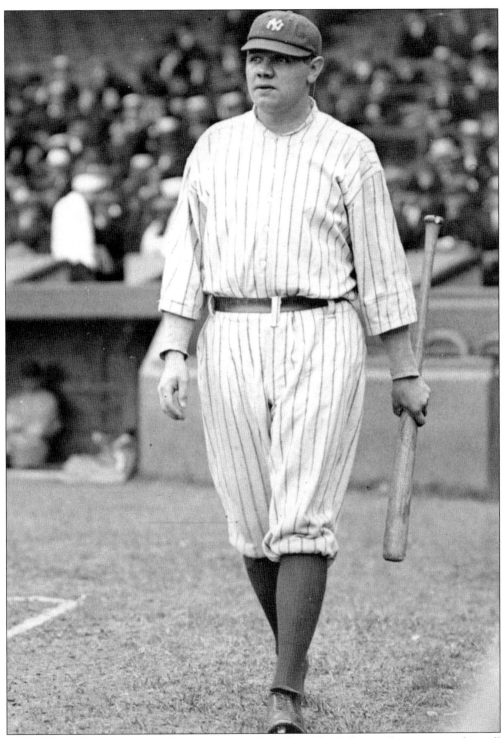

On May 1, 1920, Ruth hit his first home run as a Yankee. The ball actually went over the wall of the Polo Grounds. Ruth preferred to use a 44-ounce bat, a large bat for the time. People would come to the games just to watch him swing that bat.

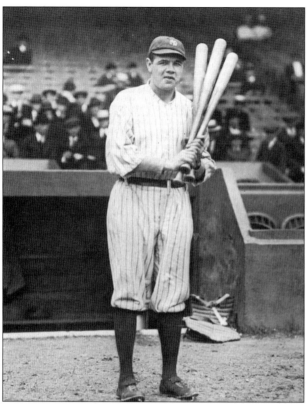

In 1920, Ruth's first year, the Yankees finished only three games out of first place and drew more than one million fans to their home games. This bothered John McGraw, who had allowed the Yankees to share the Polo Grounds with the Giants. The Giants had attracted only two thirds of that number.

Fans and reporters would gather whenever the Babe practiced his swing. Seen here in his first season as a Yankee, the Babe warms up and thrills the crowd.

To "eat, drink, and be merry" definitely applied to Babe Ruth. He was notorious for breaking curfews and going on excessive eating and drinking binges. Here, he poses for a publicity photograph before a night out on the town.

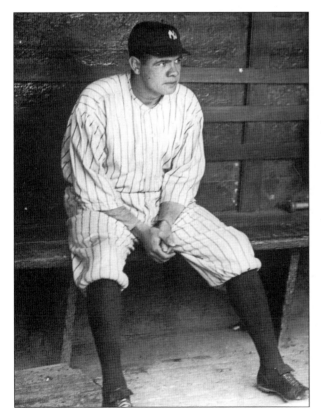

The Babe poses on the bench at the end of the 1921 season. Ruth had two great seasons and salaries to go with them. He was paid $20,000 in 1920, $30,000 in 1921, and had just signed a five-year contract for $52,000 a season.

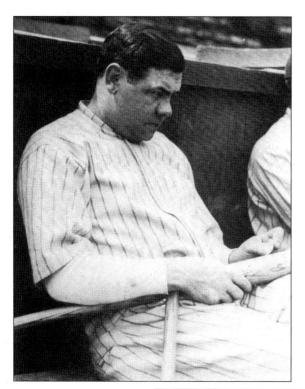

Ruth's legendary nightlife finally caught up with him in 1922. He was fined several times for being insubordinate and was suspended five times before the season was over. His agent advised him to straighten out. By spring training, Ruth was pounds lighter and ready to play in the new stadium that the club had built.

It was well known that Ruth loved kids and attention. To children, he was the best. The press would take any advantage to photograph Ruth, and most of the time, the Babe would let them. Here, Ruth stands among his young fans in 1922.

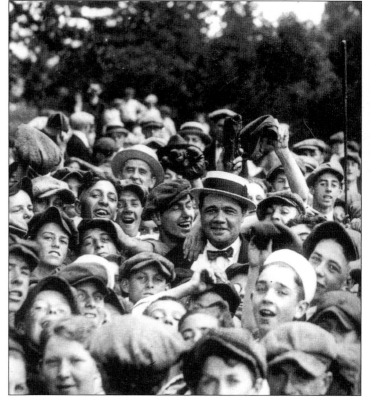

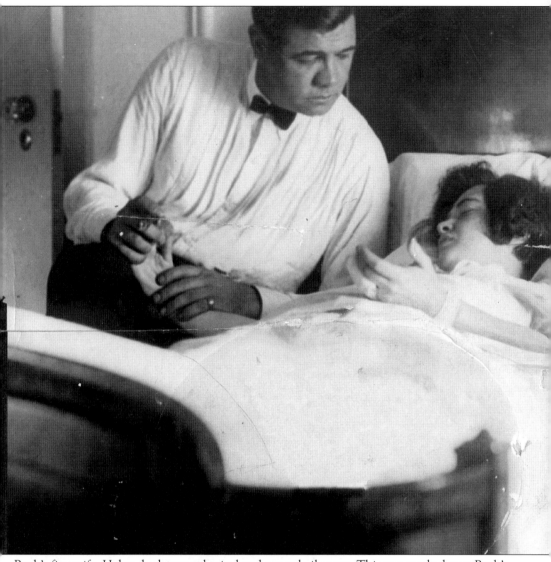

Ruth's first wife, Helen, had many physical and mental ailments. This was partly due to Ruth's "known" social life. By the late 1920s, theirs was a marriage in name only. For good public relations, the Yankee management tried to show Ruth as a caring and concerned individual and took this publicity photograph of Ruth visiting his wife at the hospital. On January 11, 1929, Helen died in a fire in her Massachusetts home.

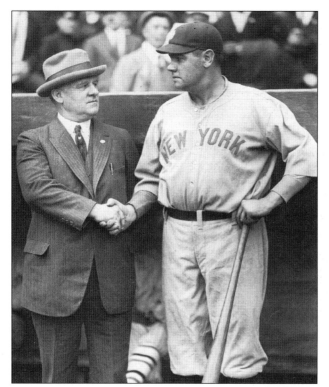

Before the start of the first game of the 1923 World Series, the Babe shakes hands with the manager of the New York Giants, John McGraw. McGraw would suffer his first major loss against the Yankees in this series. Ruth recorded the highest season average of his career (.393). He had 205 hits and 41 home runs, stole 17 bases, and drove in 131 runs. He led the league in runs batted in, slugging percentage, total bases, runs scored, and home runs.

On July 5, 1924, at Washington's Griffith Stadium, Ruth was chasing after a fly ball in foul territory and knocked himself out. The trainer, Doc Woods, applied ice to the Babe's head and eventually revived him. In this photograph, concerned fans crowd over the wall to see while the guards order them back.

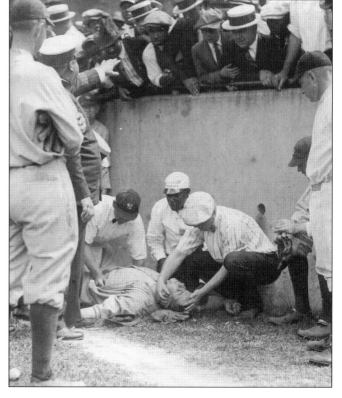

After his successful season in 1923, Ruth (seen here in 1924) went on again to lead the league in batting average and home runs and finished second in runs batted in.

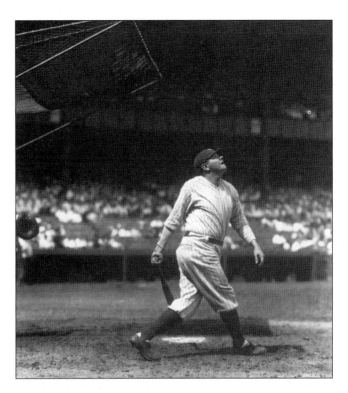

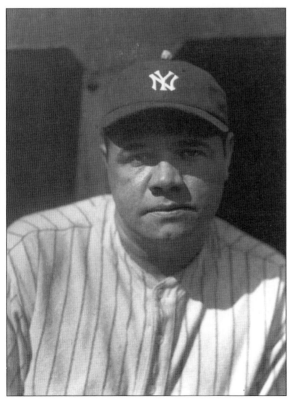

This is Charles M. Conlon's classic 1924 pose of Babe Ruth coming from the dugout. That season was Ruth's second straight season of 200 or more hits. He batted .378 and became the first Yankee to win a batting title.

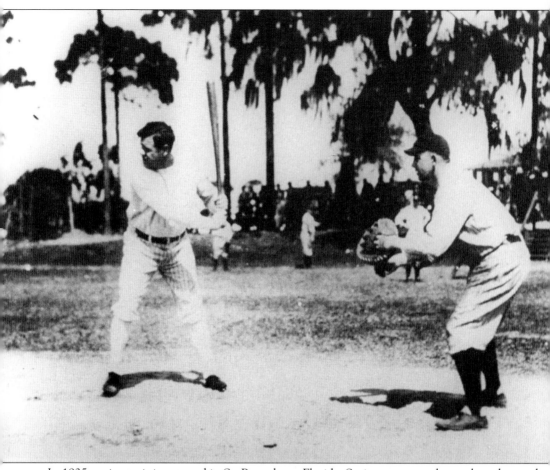

In 1925, spring training started in St. Petersburg, Florida. Spring camp was located on the south shore of Crescent Lake. Here, the Babe is taking practice hits. The Babe, a short time after this picture was taken, collapsed and was hospitalized. He would be out of the lineup until June. Personal problems with his wife, as well as his drinking and carousing, caused an ulcer, which was surgically treated.

Ruth returned after his spring training collapse and hospitalization on June 1, 1925. Again, he started violating curfews, carousing, and causing problems with the Yankees management. On August 29, 1925, Miller Huggins fined him $5,000, causing Ruth to refuse to return. Ruth finally apologized to Huggins and returned on September 7, 1925. The season was a disaster for Ruth and for the Yankees, who finished in seventh place. Sportswriters started to say that Ruth was washed up. Ruth made up his mind to change his ways and started to train for spring season.

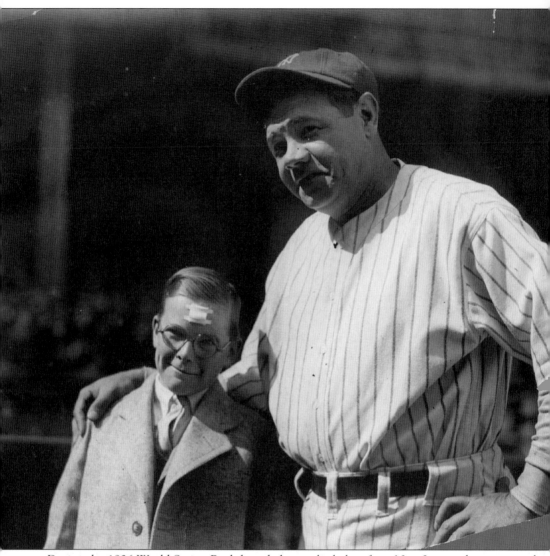

During the 1926 World Series, Ruth heard about a little boy from New Jersey who was gravely ill and in the hospital. While visiting the boy, Ruth promised to hit a home run for him in the third game of the series. Ruth actually hit three home runs that day. The young boy, Johnny Sylvester, got well enough to visit the Babe at Yankee Stadium in 1928.

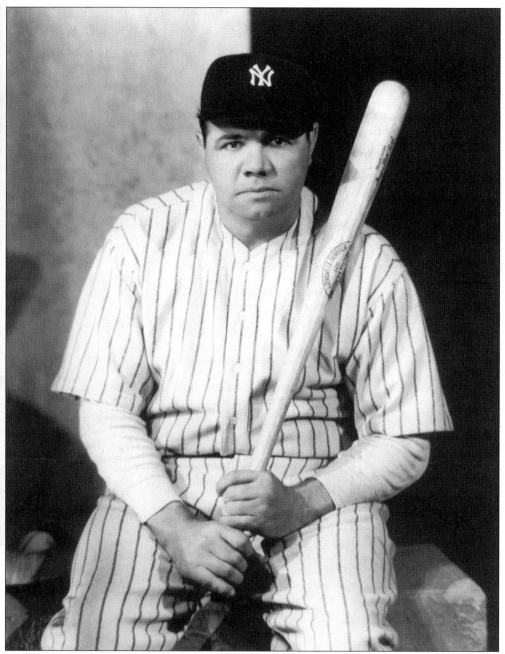
This classic image of Babe Ruth was taken by photographer Nikolas Muray in 1927. The Babe was at the height of his career, setting a record in home runs.

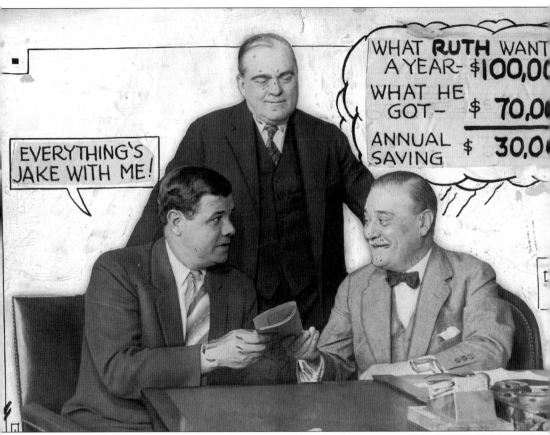

By the late 1920s, Ruth was the highest-paid baseball player in either league. Ruth would always joke that he got more money than the president did because he had a better year. This photograph shows Ruth agreeing to his new contract. The press added their comments for the newspapers to print.

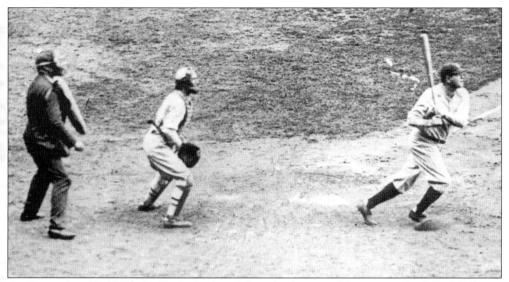

On September 30, 1927, the Yankees played their final game of the season. Ruth had 59 home runs going into the game. Tom Zachary was pitching for the Washington Senators. In the eighth inning, Ruth hit his 60th home run. As the crowds cheered, Ruth jogged around the bases slowly, making sure he touched each base, and then imbedded his spikes into the rubber home plate.

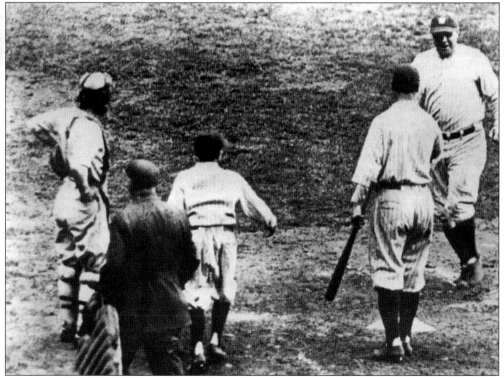

As Ruth came home for his 60th home run in the last game of the 1927 season, Lou Gehrig was the first to shake his hand and congratulate him.

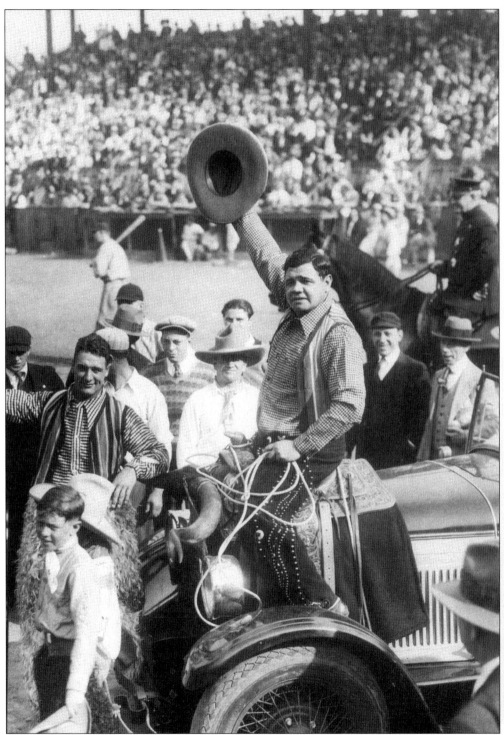

Coming off the height of the 1927 and 1928 seasons, Babe Ruth and Lou Gehrig teamed up to do a postseason barnstorming tour, with crowds packing the stadiums to see them. Here, Ruth and Gehrig dress up as cowboys to advertise an upcoming rodeo at Madison Square Garden.

Four
THE HOUSE WHERE LEGENDS GROW

By 1921, the Yankees knew they had overstayed their time at the Polo Grounds and searched for a new stadium location. On February 9, 1921, the club purchased 240,000 square feet of land that was once part of millionaire William Waldorf Astor's estate near Crowell's Creek in the Bronx. The price of the property was approximately $600,000.

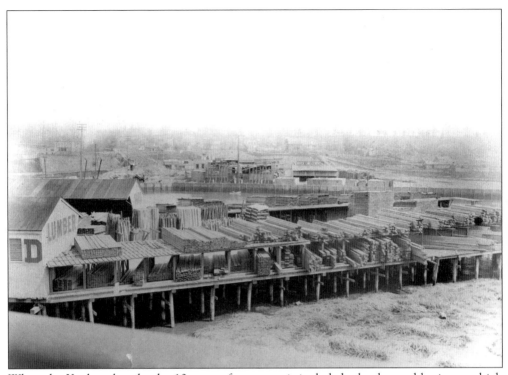

When the Yankees bought the 10 acres of property, it included a lumberyard business, which was surrounded by a huge rock field. Originally, this property had been farmland owned by John Lion Gardiner during the Revolutionary War.

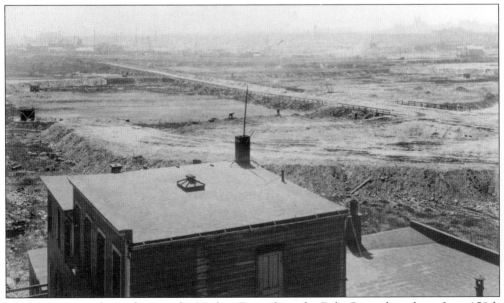

The property was located across the Harlem River from the Polo Grounds and ran from 158th Street to 161st Street on River Avenue.

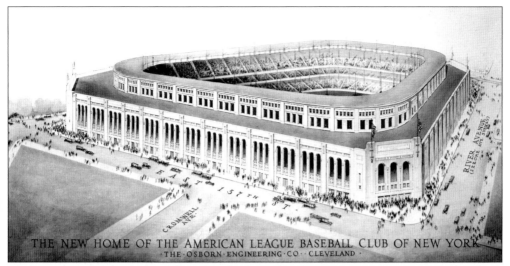

THE NEW HOME OF THE AMERICAN LEAGUE BASEBALL CLUB OF NEW YORK
· THE · OSBORN · ENGINEERING · CO · · CLEVELAND ·

The company that built the Polo Grounds, the Osborn Engineering Company of Cleveland, was hired to design the new stadium. The company's original design had the stadium roofed and triple-decked all the way around; however, that concept was abandoned and modified.

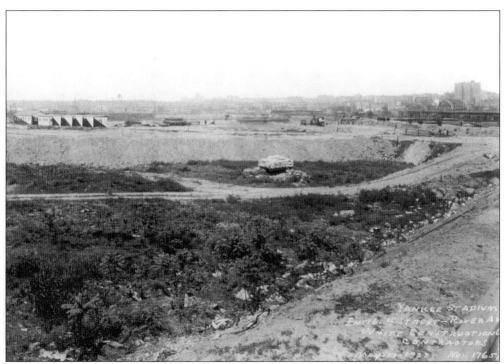

The location was considered ideal for construction because of the granite bedding and accessibility to major roads for construction crews.

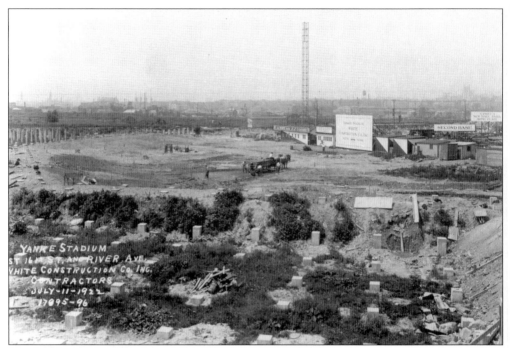

The building project was awarded to the White Construction Company, and work started at the beginning of May 1922. The contract included a clause that stated work would be completed by April 23, 1923, opening day. A large white sign advertises White Construction Company. To the right is a smaller sign showing the location for second base.

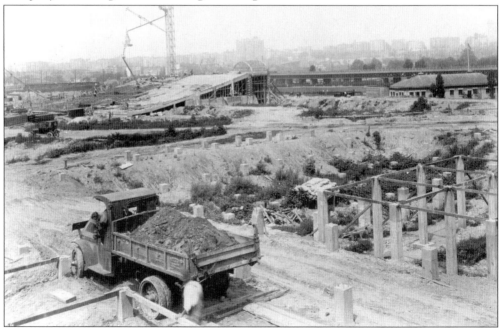

Cement blocks have just been placed for the bleacher section in the outfield, and work has started in the grandstands behind home plate. Trucks bring in fill dirt to place in the holes to cover the piles. More than 45,000 cubic yards of earth were needed to fill and level the ground.

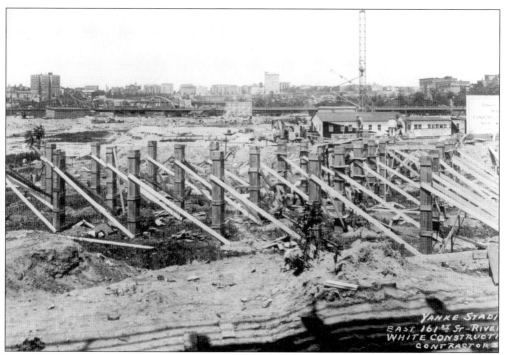

In June 1922, wood columns were prepared for pouring cement into the ground base that would support the grandstand behind home plate. More than 20,000 yards of concrete were used.

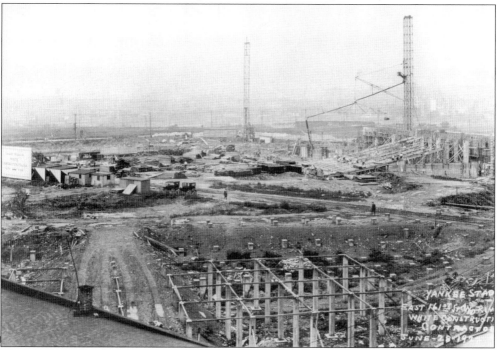

This photograph, dated June 28, 1922, details the work on the first level of the concrete grandstand. The foreground shows the installed piles for the outfield bleachers. These piles would eventually be covered by dirt and concrete.

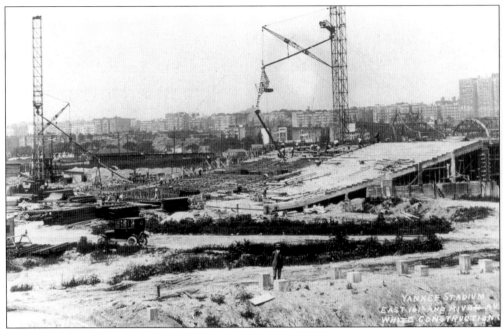

On July 11, 1922, the large steel pillars started going into place. These pillars would support the second and third tiers of seats. Note the use of skyscraper cranes. The stadium would contain more than four miles of water and electric piping.

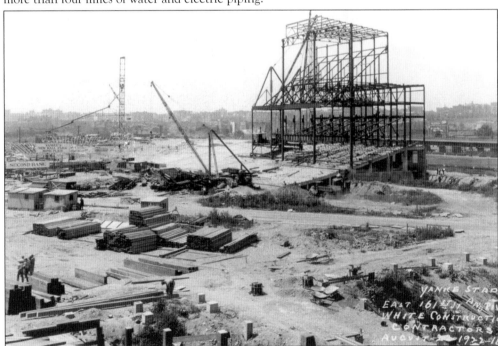

By August 1922, the contractors had started erecting the second and third tier metal framing. A roadway was constructed between second base and the outfield to accommodate trucks bringing in steel frames. Wood to be used for the outfield bleachers is stacked in the center field area.

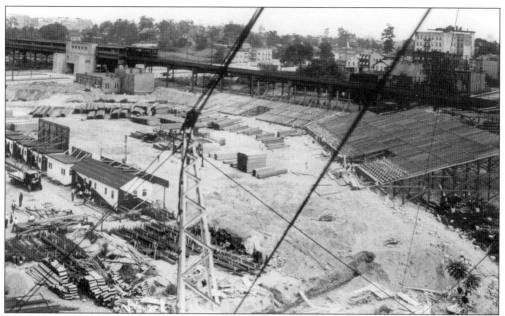

In an interesting photograph taken by a crewman from the top of the crane, the camera pans toward the first-base line and outfield. In the background are the elevated subway tracks. Notice how much open property space there is behind the subway. The subway has arrived at the station in the far left background.

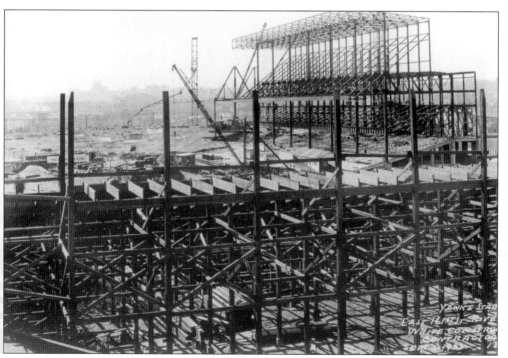

By September 5, 1922, not only had the second and third tier frames been completely placed on the third-base side, but the crews were busy building the outfield bleachers. There were 135,000 steel castings used for the grandstand seats.

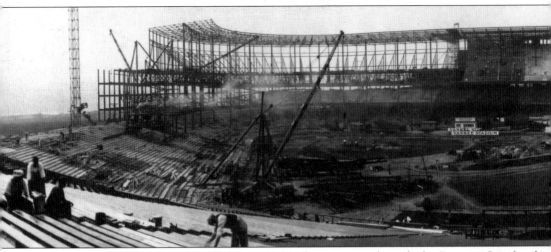

More than 950,000 feet of Pacific Coast fir planks were sent through the Panama Canal to be used for the construction of the bleachers. This view from the bleacher section on the first-base line gives an idea of the amount of wood used. Before this location was picked, several other sites were proposed. Property in Long Island City was considered but was quickly eliminated as

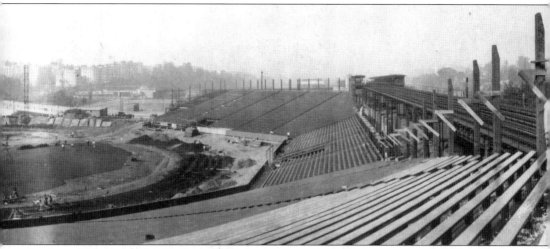

too far away from major transit. An actual contract was drawn up for property for sale by the Hebrew Orphan Asylum, but that also fell through. At one point, Jacob Ruppert even considered building the stadium over the Pennsylvania railroad tracks in the downtown Manhatten area, but the government refused the plan.

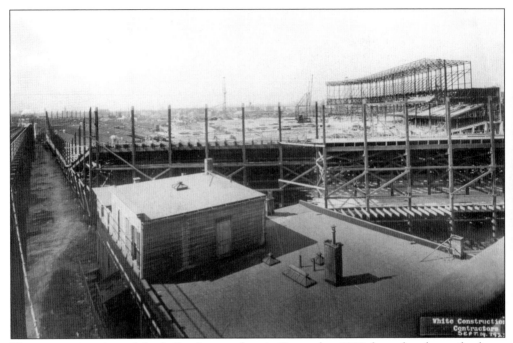

This interesting view of the ballpark was taken in September 1922 from the elevated subway platform. One of the reasons this location was picked for the stadium was the accessibility of mass transit.

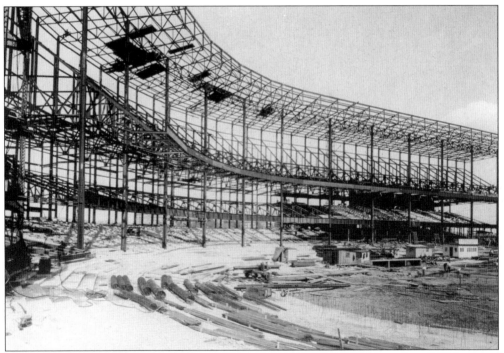

Yankee Stadium was to be the first three-tiered ballpark ever built. More than 2,200 tons of structural steel and a million screws were used. A copper facade was hung from the top of the third tier.

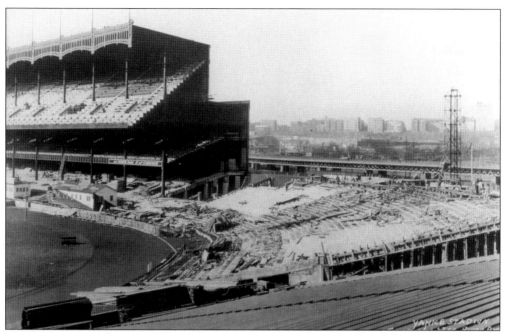

By January 2, 1923, the three tiers had been completed and the construction crews were finishing up the outfield bleachers. The copper facade, which hung 16 feet down from the top of the tier, was complete. That facade would become a Yankee trademark for the stadium.

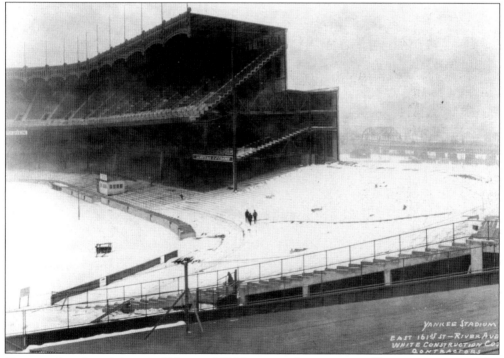

Construction slowed down in February 1923 because of a snowstorm. However, as soon as the snow melted, the crews were back to work. Construction time was limited due to the completion date contracts set for opening day in April.

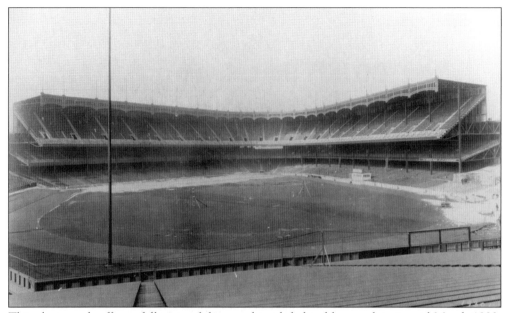

This photograph offers a full view of the grandstands behind home plate in mid-March 1923. The crews were still contending with some work on the outfield bleacher section. The crews had placed more than one million square feet of sod in November. Some of the sod was replaced when it snowed in February. The Yankees were already at their spring training site in St. Petersburg, Florida, wondering if the stadium would be ready for opening day in April.

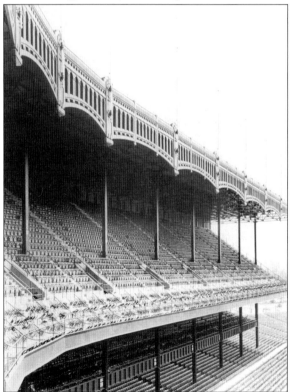

With just two weeks until opening day, construction crews put the finishing touches to the grandstand, including fastening all the bleacher chairs to the cement base. The stadium featured more than 60,000 seats. Note the detailed work on the copper facade hanging over the third tier.

Pictured is a rare side view of the completed grandstand. To accommodate Babe Ruth's southpaw swing, a 296-foot right field foul line with a low fence was built.

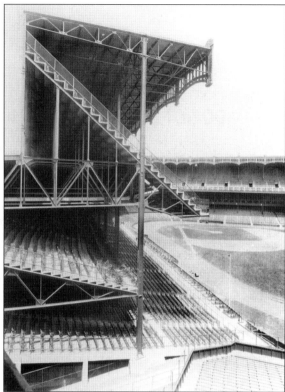

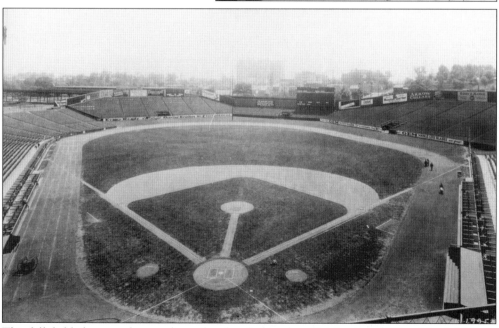

This full-field photograph was taken a few days before the official opening. The right field fence was 296 feet away along the foul line and 367 feet to dead right field. The left field line was also a short 301 feet down. Advertising signs were already in place, along with the enormous electric scoreboard in center field. The scoreboard also provided scores of out-of-town games.

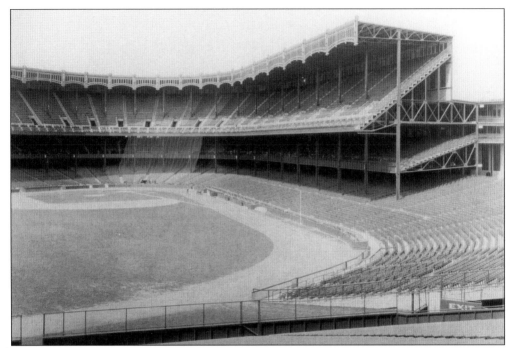

Looking toward home plate from center field, this view shows the foul ball netting already in place for the opening game. At 500 feet from home plate, center field was considered a vast wasteland for sluggers.

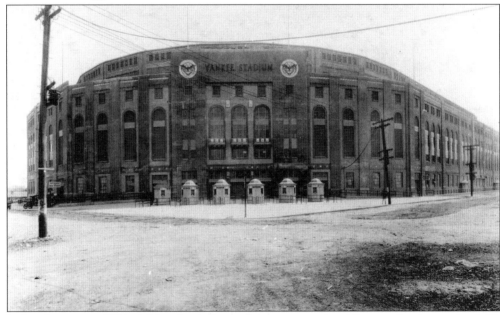

In less than a year (284 working days), the stadium was completed for opening day on April 18, 1923. The project cost $2.5 million and was originally named "the Yankee Stadium." It would soon receive the nickname "the House That Ruth Built" due to fitting the field dimensions to Ruth's hitting style. The ballpark stretched from 157th Street to 161st Street, from River Avenue to Doughty Avenue.

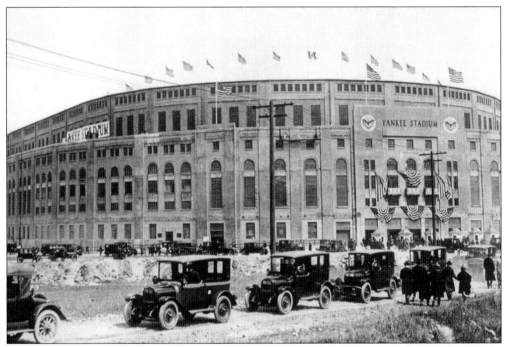

This classic Yankee photograph shows some of the opening-day fans arriving by car. There were no official parking lots, so most individuals parked their cars along the dirt roads that lined the stadium. A majority of the fans arrived by elevated railway. The traffic on the subways was extremely heavy, but there were no breakdowns and very few delays.

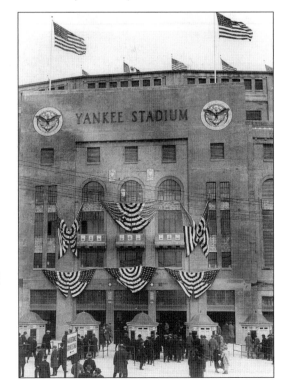

Opening-day attendance is believed to have exceeded 74,000 fans, which included standing room. The stadium had 36 ticket booths and 40 turnstiles available to make it easy for the fans to buy tickets and enter the building. It is estimated that more than 25,000 disappointed fans failed to get in. Grandstand tickets were priced at $1.10.

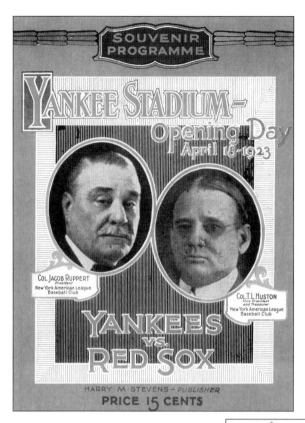

Yankee Stadium's opening-day program featured the photographs of both owners. The Stevens Brothers printing company changed the price from the usual 5¢ program to 15¢, allowing the company to add stadium information and call them souvenir programs.

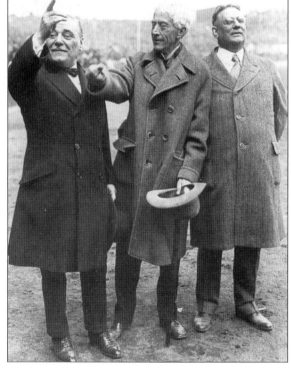

During the pregame ceremonies, owners Jacob Ruppert (left) and Tillinghast L'Hommedieu Huston (right) were introduced to the crowd, followed by the introduction of the commissioner of baseball, Judge Kenesaw Mountain Landis (center).

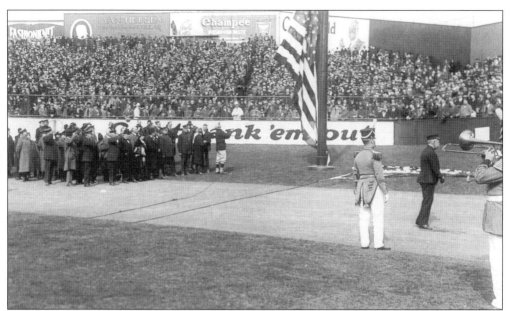

At 1:00 p.m., the pregame celebration began. The 7th Regimental Band, led by John Philip Sousa, marched to the flagpole, where Yankee manager Miller Huggins and Red Sox manager Frank Chance raised the American flag as the band played "The Star-Spangled Banner."

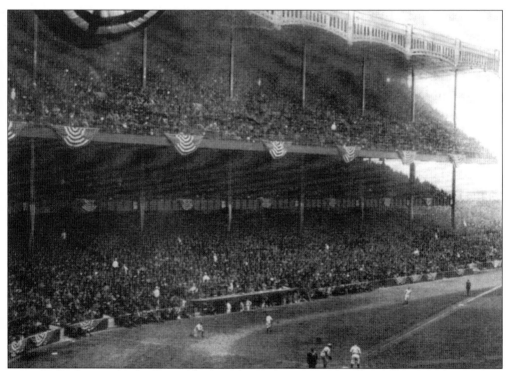

This opening-day photograph shows the Yankees playing the Boston Red Sox in the first game at Yankee Stadium. The Yankees won 4-1. A three-run homer by Babe Ruth gave him the honor of hitting the first home run in the new stadium.

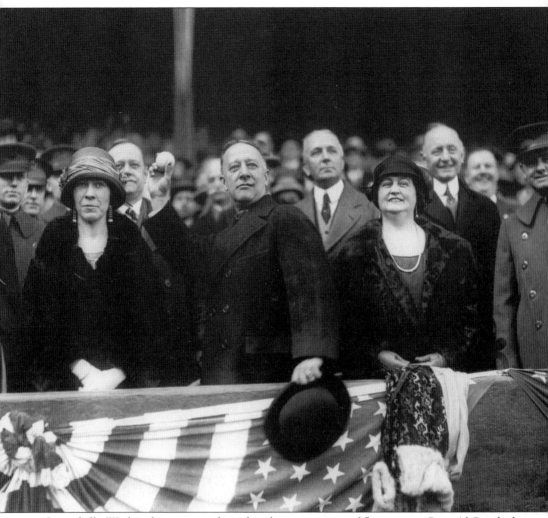

On a chilly Wednesday opening day, after the ceremonies of flag raising, Gov. Al Smith threw out the first ball to catcher Wally Schang. Calling balls and strikes was Tom Connolly, the same umpire who had called the Highlanders first league game in 1903.

Five

THE YANKEES
ACHIEVE GREATNESS

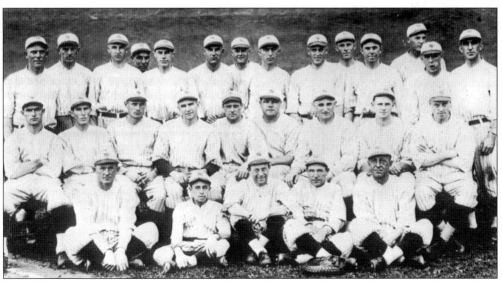

The 1921 Yankees were the organization's first American League champions. The Yankees went on to the World Series against the New York Giants but lost five games to three.

Fred "Crooked Nose" Hofman played for the Yankees from 1919 to 1925 and was mostly a backup catcher. Hofman, who was the Babe's personal warm-up catcher from 1920 to 1924, was also his drinking buddy during the evening social hours.

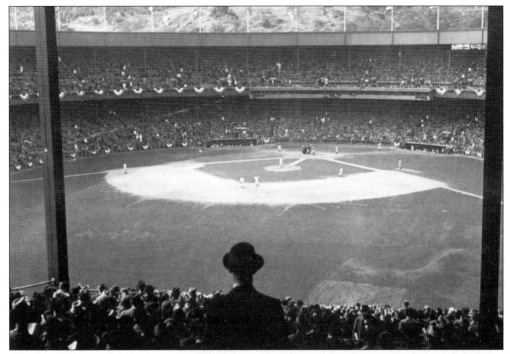

The World Series of 1921 between the New York Giants and the New York Yankees was played completely at the Polo Grounds, since the teams were still sharing the facility.

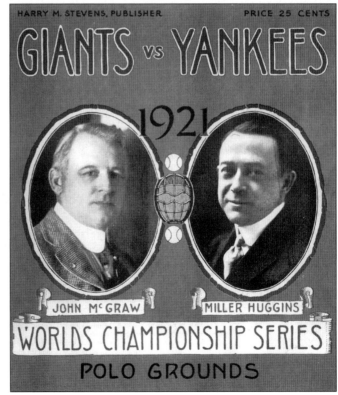

Of all the teams the Yankees could have played in their first World Series, it was New York Giants. Pictured is the souvenir program cover from the first day of the 1921 series at the Polo Grounds.

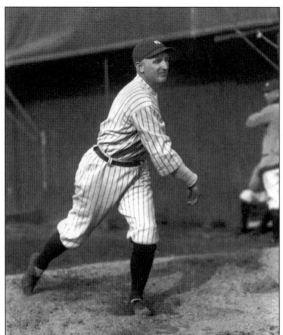

Carl Mays pitched for the Yankees from 1919 to 1923, which included the 1921 and 1922 World Series. Many players found it hard to associate with him because of his unpleasant personality. For the 1920 and 1921 seasons, Mays won 26 and 27 games, respectively. Tragedy would mark his career when on August 16, 1920, Mays threw a pitch that killed the popular Cleveland shortstop Ray Chapman.

In 1922, with the team in first place, Ed Barrow made yet another deal with the Red Sox, obtaining shortstop Everett Scott and two pitchers—Sam Jones and Joe Bush. Scott, who had been with Boston since 1916, had not missed a game and continued his playing streak with the Yankees. When he left the Yankees in 1925, he had a total of 1,307 continuous games. Lou Gehrig later broke that record with 2,130 games as the Yankees' first baseman.

In this photograph, taken before the 1922 series, Giants manager John McGraw (left) shakes hands with Yankees manager Miller Huggins. Although the Giants beat the Yankees four games to zero, McGraw had made it clear to the Yankees that they had to leave the Polo Grounds before the 1923 season. The increased popularity of the Yankees annoyed McGraw.

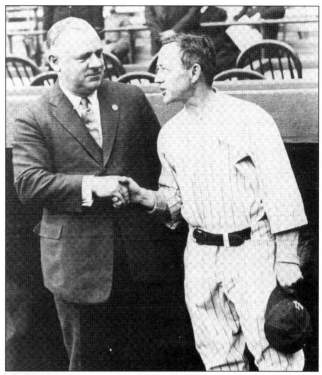

Brothers Irish (left) and Bob Meusel pose before the 1922 World Series. Bob Meusel was good friends with Babe Ruth, and both were suspended for part of the season for doing an unauthorized barnstorming tour before the season started.

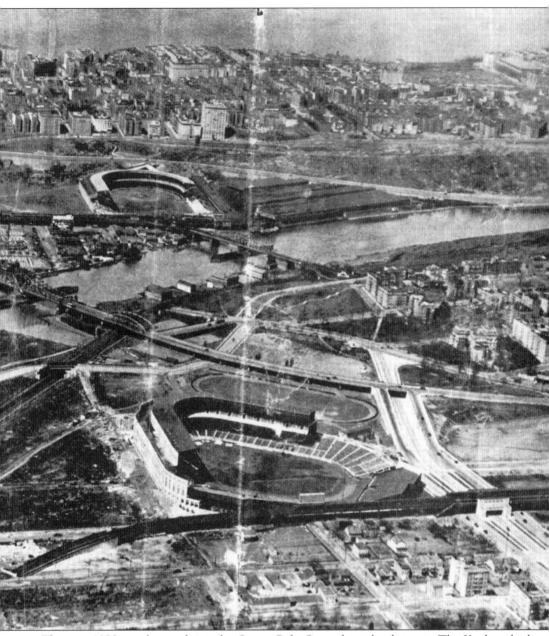

This rare 1923 aerial view shows the Giants Polo Grounds in the distance. The Yankees built their stadium just a river and a bridge away, which angered Giants manager John McGraw. Within the next year, the Polo Grounds placed a roof over the outfield bleachers.

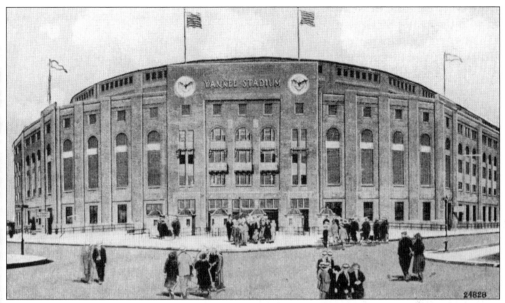

In this late-1920s postcard view of Yankee Stadium's front entrance, the road in front of the stadium has finally been paved, replacing the dirt roads of earlier years.

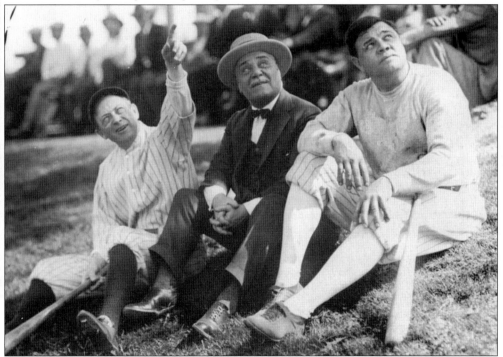

Tillinghast L'Hommedieu Huston, returning from France after World War I, was never happy with Jacob Ruppert's decision to hire Miller Huggins. Nevertheless, Ruppert backed Huggins. Finally, on May 21, 1923, all of Huston's financial interests for the Yankees were transferred to Jacob Ruppert, making him the sole owner. For half of his share of the Yankees, Huston received a tidy profit of $1.5 million. Ruppert is pictured here with his two great investments, Miller Huggins (left) and Babe Ruth during spring training in St. Petersburg, Florida.

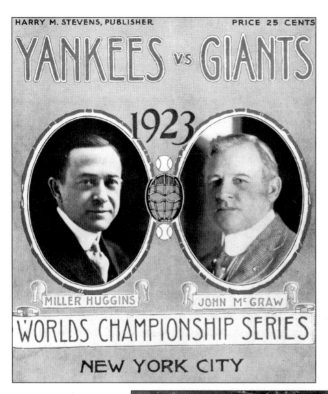

HARRY M. STEVENS, PUBLISHER PRICE 25 CENTS

YANKEES vs GIANTS

1923

MILLER HUGGINS JOHN McGRAW

WORLDS CHAMPIONSHIP SERIES

NEW YORK CITY

Pictured is the program cover of the 1923 World Series. The photographs are of Yankees manager Miller Huggins (left) and Giants manager John McGraw. Depending on which stadium sold the program, the cover reversed the position of the managers' photographs and team names.

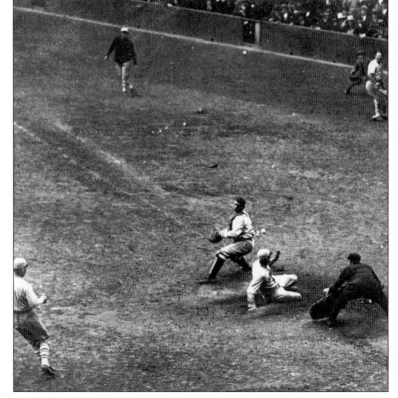

Giants player Casey Stengel slides home with the winning run on an inside-the-park home run in the first game of the 1923 series. The Giants won 5-4.

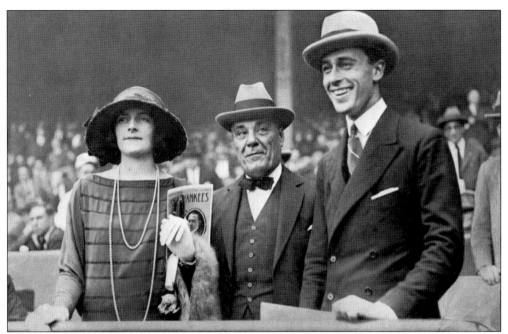

In 1923, many celebrities and political figures showed up for the first World Series held in Yankee Stadium. Owner Jacob Ruppert entertained Lord and Lady Mountbatten at the Polo Grounds and Yankee Stadium as the Yankees battled it out with the Giants. That year was the first time the Yankees won the World Series. They beat the Giants four games to two.

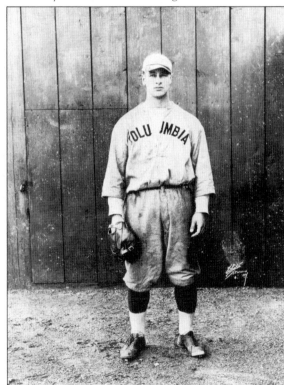

In 1923, when the Yankees won the World Series for the first time, Lou Gehrig was Columbia University's star player. He signed a contract with the Yankees at the end of his college season. Within two years, he was the Yankees' permanent first baseman, a position he held for 14 years.

This 1925 image shows a young Lou Gehrig, who was then just taking over first base from Wally Pipp. Gehrig actually played for the Yankees in 1923 and 1924 but only played 23 games as a replacement fielder.

On June 1, 1925, during batting practice, veteran first baseman Wally Pipp was hit on the side of the head, causing Miller Huggins to replace him with Gehrig at first base. Gehrig had only played in 23 games prior to this but continued to do well at the position and became the regular Yankee first baseman.

Pictured here in 1925, Leo Durocher would not make his mark in baseball history as a Yankee rookie. His active years with the Yankees were 1928 and 1929, including batting twice during the 1928 World Series. Durocher played for the St. Louis Cardinals before becoming manager of the New York Giants, where he found his fame.

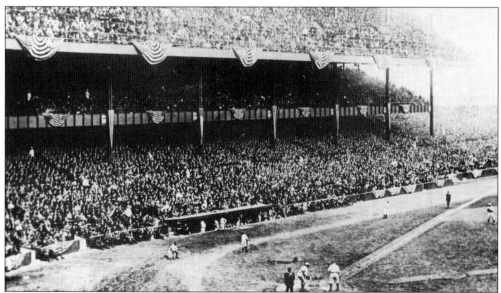

In the 1926 series, Lou Gehrig had been playing two years as first baseman for the Yankees. This series was the the first of many in which he would play an active part. The Yankees lost to the St. Louis Cardinals four games to three.

NEW YORK

HOME **ROAD**

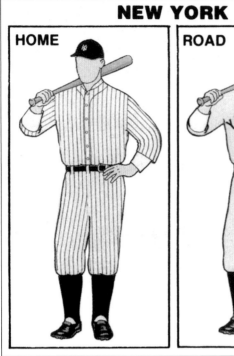

The team had kept the same style home uniforms since 1922, but in 1927 the team decided to change their road uniform to show the name of the club rather than the city. The team was so popular by 1927 that everybody recognized the fact the Yankees were from New York. The road uniform would change back to read New York for the 1931 season and remains that way today. (Courtesy Marc Okkonen.)

Starting in 1925, the Yankees spring training camp was at Crescent Lake Park in St. Petersburg, Florida. Many of the players stayed at the famous Don Cesar Hotel. Babe Ruth would always stay at the Vinoy Hotel in St. Petersburg, where he felt he was closer to the night life. Here Gehrig smiles for the camera as he practices for the upcoming 1927 season.

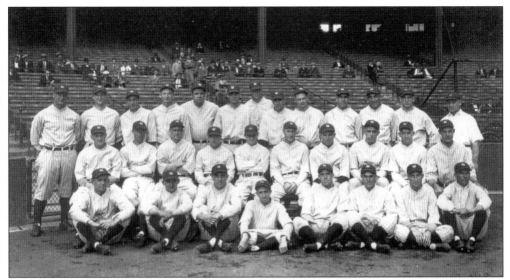

The 1927 Yankees pose for their team picture. Many fans consider this team to be the best in Yankee history. Their four starting pitchers had each won 18 or more games that season. This team included the legendary Murderers Row of Yankee players. Their season record was 110 wins and 44 losses.

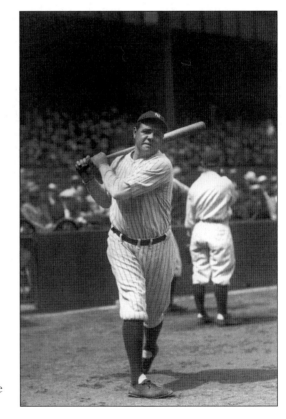

In 1927, the Yankees had a batting lineup that was a terror to face for any pitcher. The group was nicknamed Murderers Row. The Babe led the pack with an incredible season, including his 60 home runs, which set a record for the fourth time in nine years. Ruth batted third in the lineup. He would be with the Yankees from 1920 to 1934.

Starting in 1925 as the Yankee first baseman, Lou Gehrig was on his way to numerous records. He likewise had a terrific season in 1927. Batting in the clean-up position (fourth in the lineup), Gehrig battled Ruth for home runs and finished with 47. Gehrig would be voted the American League's most valuable player in 1927. He played for the Yankees from 1923 to 1939, when he retired due to the disease that would take his life. Known today as Lou Gehrig's disease, the illness involves in the breakdown of muscle tissue.

Earle Combs played center field for the Yankees. He started in 1924 and remained until 1935. His lifetime batting average was .325. In 1927, Combs hit .356 and led the league with 23 triples. Combs batted first in the lineup.

120

Mark Koenig, the Yankees' shortstop, started with the team in 1926 and played with them until 1930, when he was traded to Detroit. His best year with the Yankees was 1928, when he batted .349. Koenig batted second in the lineup. In the 1927 World Series, he hit .500, leading all batters.

"Silent Bob" Muesel was a terrific player but was overshadowed by Ruth and Gehrig. Muesel played outfield for the Yankees from 1920 to 1929. He hit over .300 seven times, with his average in 1927 at .337. In 1925, he hit 33 home runs and led the league in runs batted in. He had a powerful throwing arm, which players said could "hit a dime at 100 yards and flatten it against the wall." He batted fifth in the lineup.

Tony Lazzeri, the second baseman, played for the Yankees from 1926 to 1937. He batted over .300 five times. His highest batting average was in 1929, with .354. In 1927, he averaged .309 and had more than 100 runs batted in. Lazzeri batted sixth in the lineup.

Joe Dugan played third base for the Yankees from 1922 to 1928. "Jumping Joe" batted seventh in the lineup. His batting average for the 1927 season was .269. Dugan was one of the Babe's inner circle of friends.

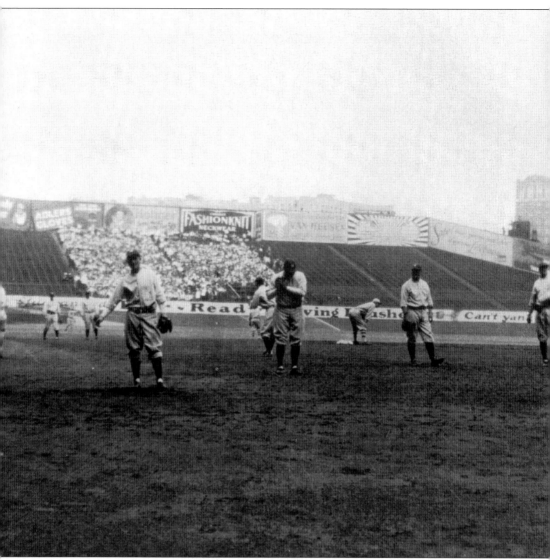

Five members of Murderers Row line up around the sideline to warm up. From left to right are Bob Muesel, Mark Koenig, Babe Ruth, Lou Gehrig, and Earle Combs.

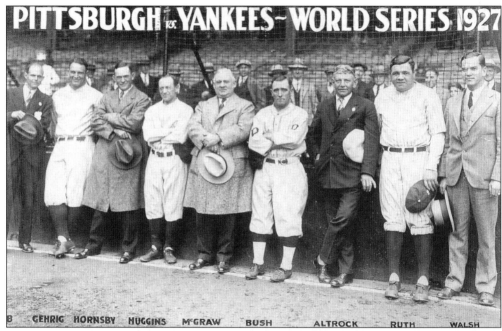

This poster advertises the 1927 World Series, with the Yankees playing the Pittsburgh Pirates. The photograph shows the team managers, Babe Ruth, Lou Gehrig, and some famous ball players, including the unhappy manager of the New York Giants, John McGraw. The Yankees swept the series 4-0.

Miller Huggins was short in stature but a giant when it came to managing the Yankees. Huggins was constantly battling with Ruth to keep him on track. Throughout the 1920s, Ruppert would back Huggins's decisions. Ruppert shares a moment with his manager prior to the start of a game in 1928. Miller would only manage one more year when he would suddenly die in September 1929 of blood poisoning.

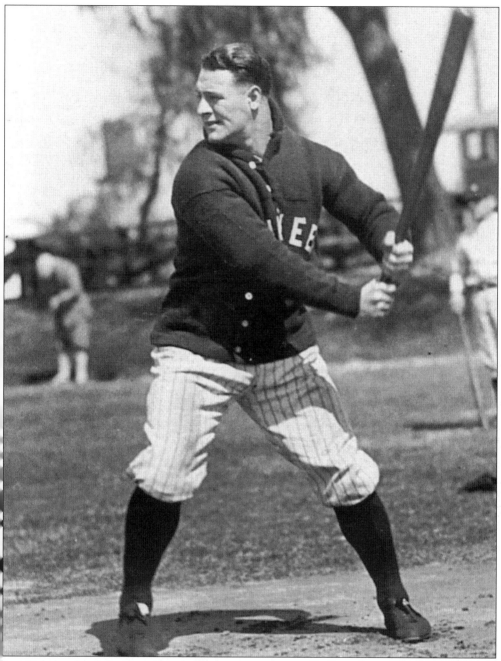
Lou Gehrig takes practice swings during spring training in St. Petersburg, Florida, in 1928.

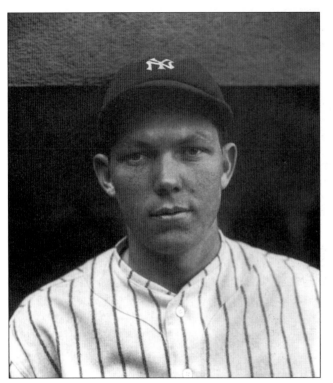

Rookie catcher Bill Dickey poses for photographer Charles M. Conlon in 1928. Dickey played very little that season but would become the Yankees' main catcher until 1946. Dickey also became the best friend and roommate of Lou Gehrig. Dickey would himself become a Yankee legend.

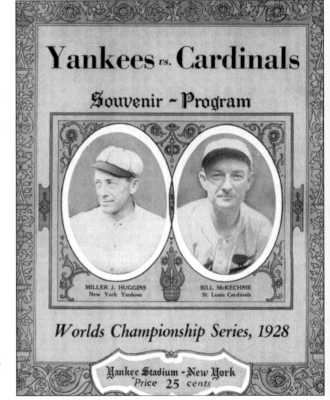

Pictured is the program cover for the 1928 World Series, between the Yankees and the St. Louis Cardinals. The Yankees would sweep the Cardinals and make up for their loss to the Cardinals in the 1926 series. Note that Miller Huggins is not in a Yankee uniform.

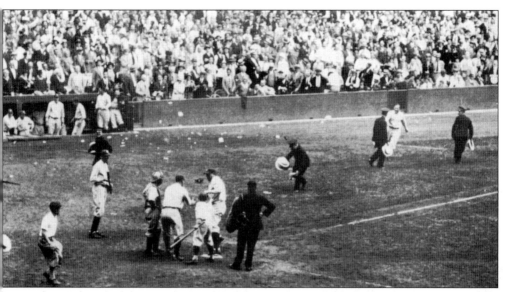

Just as the Yankees had done to the Pittsburgh Pirates in 1927, the Yankees won the 1928 series four games in a row against the St. Louis Cardinals. Ruth is seen stepping on home plate after hitting his third home run in the last game of the series.

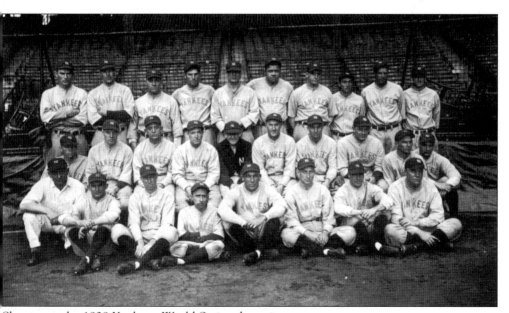

Shown are the 1928 Yankees, World Series champions.

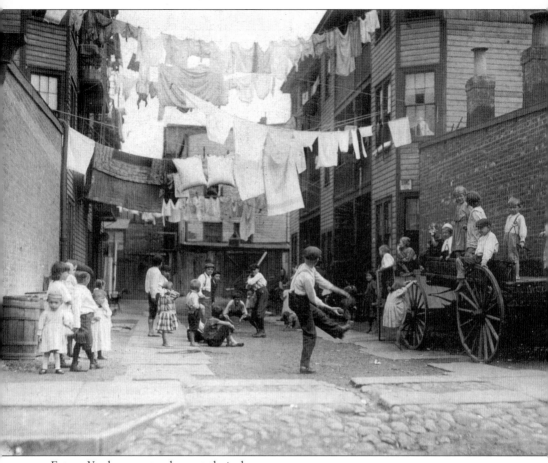

Future Yankee greats play out their dreams.